DRAW YOUR OWN

MANGA WORLD

INVENT CHARACTERS THAT LEAP RIGHT OFF THE PAGE

DESIGN ORIGINALS

an Imprint of Fox Chapel Publishing
www.d-originals.com

ISBN 978-1-4972-0638-0

Copyright © 2023 Quarto Publishing plc

This edition published in 2023 by New DesignOriginals Corporation, www.d-originals.com, an imprint of Fox Chapel Publishing, 800-457-9112, 903 Square Street, Mount Joy, PA 17552.

The Cataloging-in-Publication Data is on file with the Library of Congress.

We are always looking for talented authors. To submit an idea, please send a brief inquiry to acquisitions@foxchapelpublishing.com.

Conceived, edited, and designed by

Quarto Publishing, an imprint of Quarto
1 Triptych Place
London
SE1 9SH
www.quarto.com

QUAR.421453

Copy editor: Claire Waite Brown
Editor: Charlene Fernandes
Proofreader: Sarah Hoggett
Managing editor: Lesley Henderson
Designer: India Minter
Designer: Karin Skånberg
Deputy art director: Martina Calvio
Art director: Gemma Wilson
Publisher: Lorraine Dickey

Printed in China

First printing

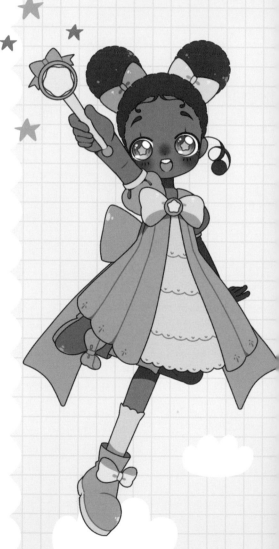

I'd like to thank my parents and Fábio for their support and inspiration through my journey as an artist.
Arunyi

CONTENTS

ENTER YOUR MANGA WORLD

"Bear" Necessities
8

Space Cadet
14

Ballerina Dreamer
20

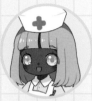
Nurse
26

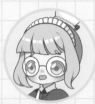
Maid
32

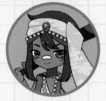
Warrior Prince
38

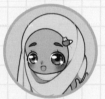
Strawberries and Cream
44

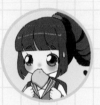
Late for School
50

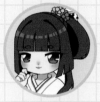
Japanese Princess
56

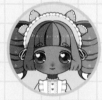
Sweet Lolita
62

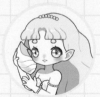
Mythical Mermaid
68

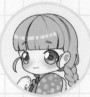
Country Cute
74

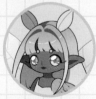
Flower Fairy
80

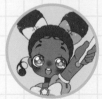
Power for Good
86

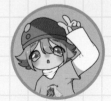
Retro Gamer
92

Sleepy Head!
98

Flying High
104

Kemonomimi Cat
110

Steampunk Scientist
116

Cyborg Superhero
122

MEET ARUNYI

HELLO! I'm Arunyi, and I'm a self-taught artist. Since I was little, I knew I wanted to be an artist. I would spend most of my time creating characters and drawing them in anime/manga style. When I turned 16, I started drawing digitally (on my computer and tablet). I was set on becoming a digital illustrator, and I have been doing it ever since! It wasn't an easy journey, but by practicing every day and searching for ways to improve I made my dream come true!

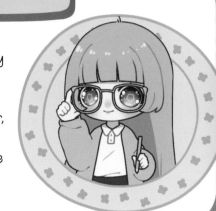

TOOLS AND MATERIALS

You don't need special tools to draw cute manga art, so I suggest you choose the ones you are most comfortable with. Here are some tools to get you started on your journey.

Use pencils for the initial drawing, some of which you will erase as you progress (B pencils are the easiest to erase).

If you choose to complete your drawings with pen, use pens with different tip sizes so you can make thick and thin strokes.

You can make your manga drawings on any paper.

Eraser

Pencil sharpener

Ruler in case you need help with proportions.

Coloring pencils or markers.

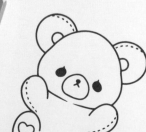

ABOUT THIS BOOK

Use the contents page to choose a character to begin with, or work through the book from beginning to end. You'll learn how to draw different types of characters, clothes, and accessories as you progress.

1 THE CHARACTER IN THEIR WORLD!

In the first pages, you'll be presented with the overall look of the character and their accessories. Each character is unique and has its own theme!

Use the color pencil indicator to gather all the colors you need.

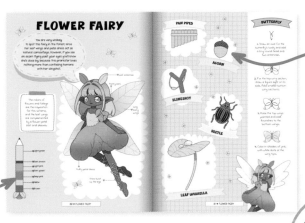

Your character has accessories to help bring their story to life.

2 CREATE THE CHARACTER

A step-by-step guide for how to draw the character. Start with the body position, then follow the red guidelines for what to draw next. You'll need to erase some of the lines as the character develops, so use your pencil lightly and use the pen once the sketch is final.

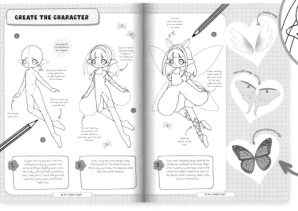

The new lines to draw are in red.

Sometimes there will be variations that you can try.

3 ADD ACCESSORIES

Here you'll learn how to draw items related to the character. Again, the red lines show you what to draw next.

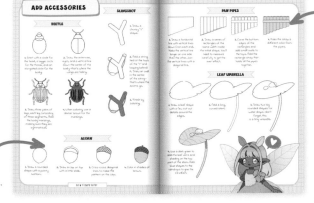

Make sure you have your colors ready to finish the image.

USE AN ERASER TO RUB OUT PENCIL LINES.

Follow the step-by-steps to create cute accessories.

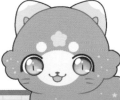

HOW TO SKETCH THE BODY

Draw the head first, then use the size of the head to work out how big to make the rest of the body. If you look at the drawing below left, you'll see a pink line that's divided into five sections: each section is the same height as the head, so my manga characters are about five heads high in total. Use circles for the joints (shoulders, elbows, hands, knees, and ankles), then connect them with lines to complete the body.

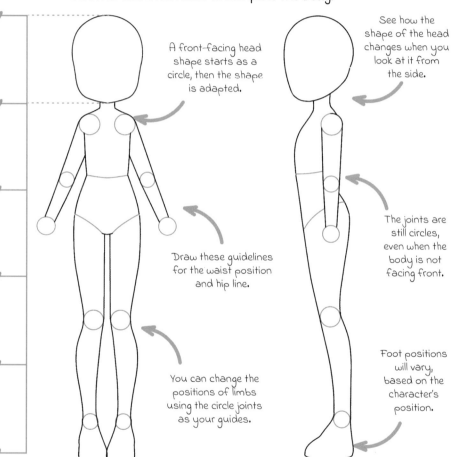

The character is about five "heads" high in total.

A front-facing head shape starts as a circle, then the shape is adapted.

See how the shape of the head changes when you look at it from the side.

Draw these guidelines for the waist position and hip line.

The joints are still circles, even when the body is not facing front.

You can change the positions of limbs using the circle joints as your guides.

Foot positions will vary, based on the character's position.

CREATE YOUR OWN CHARACTER

There are lots of ways you can adapt the 20 characters in this book. For example, you could change the color scheme, the hairstyle, or the accessories. You can even start from scratch. Start by thinking about your character's age, job, personality, and name; once you know what type of character you want to draw, you will find it easier to design them. Let their outfit and accessories show off their personality or the things they like.

ENTER YOUR MANGA WORLD

Now let's meet our wonderful manga characters.
As you do so, you'll learn lots of drawing
techniques and be inspired to create your own
original characters.

"BEAR" NECESSITIES

How many bear accessories can one girl have? In this girl's case, LOADS! From teddy bears to beanies, hair clips to bags, if it features a bear, she's got it. She even cuts bread into bear shapes to make fun sandwiches!

This girl's clothes are baggy and comfortable. The colors are inspired by nature and remind us of bears and the forests they live in.

Even her hair clip is a bear!

There's a paw print on the pompoms.

Extra lines on the hoodie make it look baggy.

Pleated plaid skirt.

Add a pattern to the pantyhose to personalize the outfit.

one line and a small dot in a lighter color show the shine on the shoes.

♥ Light yellow

♥ Light pink

♥ Medium brown

♥ Peach

♥ Green

♥ Dark brown

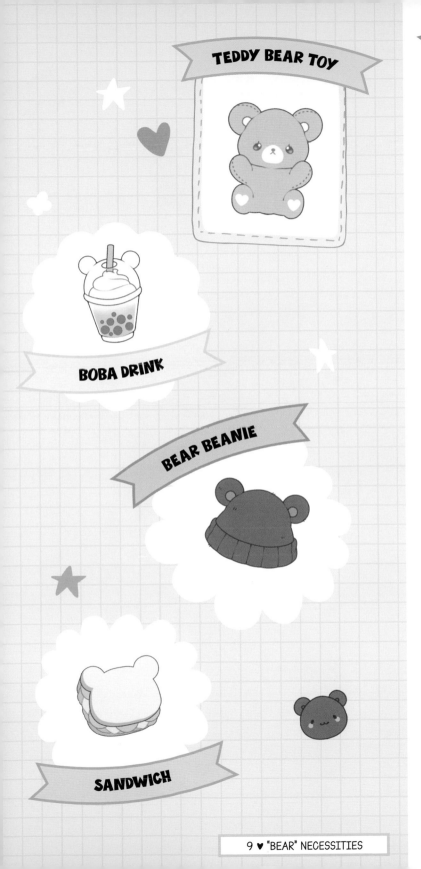

TEDDY BEAR TOY

BOBA DRINK

BEAR BEANIE

SANDWICH

BEAR BAG

1. Start by drawing a shape like three-quarters of a circle.

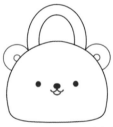

2. Add a curved handle shape on top of the bag.

3. Now it's time to add the round ears and a cute bear face.

4. Color in and add line details to the ears and bag—this helps make them look rounded.

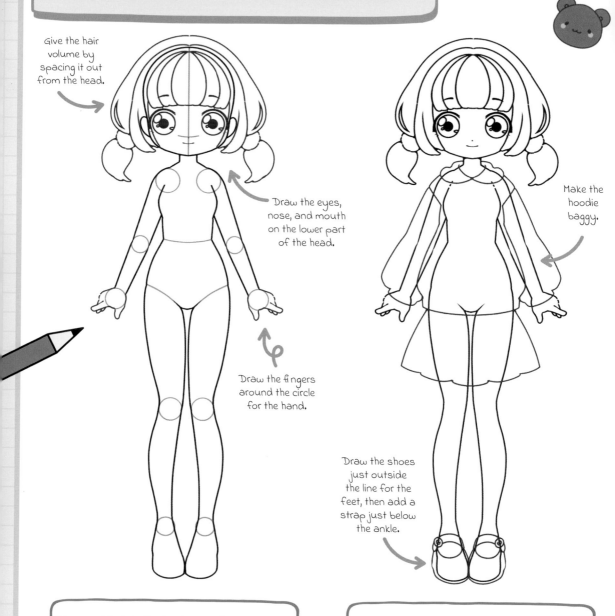

Give the hair volume by spacing it out from the head.

Draw the eyes, nose, and mouth on the lower part of the head.

Draw the fingers around the circle for the hand.

Make the hoodie baggy.

Draw the shoes just outside the line for the feet, then add a strap just below the ankle.

1. Sketch the body in a front view. The shape of the head is similar to an upside-down egg. Add the facial details, hair, and hands.

2. Draw the lines for the hoodie a little way away from the body to make it look baggy. The skirt should flare out from the body, too. Draw the outline for the shoes.

Add a few more lines to the hair.

Add details such as pompoms and, of course, a cute bear face to the hoodie.

Add folds on the hoodie and pleats on the skirt.

An extra curved line around the toes shows the soles of the shoes.

Bobby pins

Keep-it-simple hair clip

Heart-shaped hair clip

3. Add a bear hair clip, a bear pocket on the hoodie, and bear buckles on the shoes. Then have fun adding color and patterns to the skirt and pantyhose.

ADD ACCESSORIES

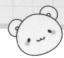

TEDDY BEAR TOY

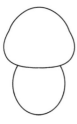

1. The bear has an egg-shaped body with a squashed circle over the top for the head. It looks like a mushroom!

2. Add round ears and rounded shapes for the arms and legs.

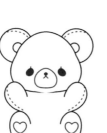

3. Add the face and other details, such as stitches and heart-shaped pads on the paws!

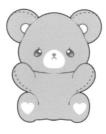

4. This bear is pink and white, with dark pink stitching. The eyes are pink with dark pink shading and a little white highlight.

BEAR BEANIE

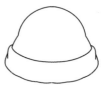

1. Start with the basic beanie shape. The lower part of the beanie is wide to give a comfortable fit!

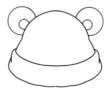

2. Add bear ears, of course!

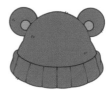

3. Color the hat and add some dark lines for folds at the same time.

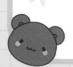

BOBA DRINK

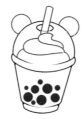

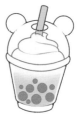

1. Let's start with the outline of a cup. The cup gets wider and rounder at the top.

2. Draw a small circle on the top of the lid, plus the outlines for the lid and base of the cup.

3. Fill the cup with boba pearls, with cream on top. Add the straw and give the lid two bear ears.

4. When you color, try to make a gradual change between the light yellow cream and the pink tea.

SANDWICH

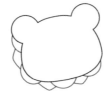

1. Start with a simple bear-head outline for the first slice of bread.

2. Add wavy lines for ingredients around the bottom edge of the bread and up one side.

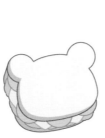

3 Add more ingredients underneath if you want. Don't forget to draw the outline of the second slice of bread under all the ingredients.

4 Color in your bread and ingredients, This sandwich is ham, cheese, and lettuce!

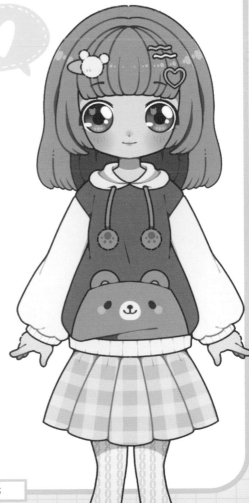

SPACE CADET

This boy is mad about space. He's learning everything he can about it and is going to be an astronaut when he grows up! He adds planet, star, alien, and spaceship stickers and patches to most of his accessories, and has lots of books about science and space exploration.

The color scheme is quite futuristic, and the elbow patches and tight cuffs on the jacket look like something a space cadet would wear.

The T-shirt has a planet motif.

Elbow patches on a jacket are practical but also very trendy.

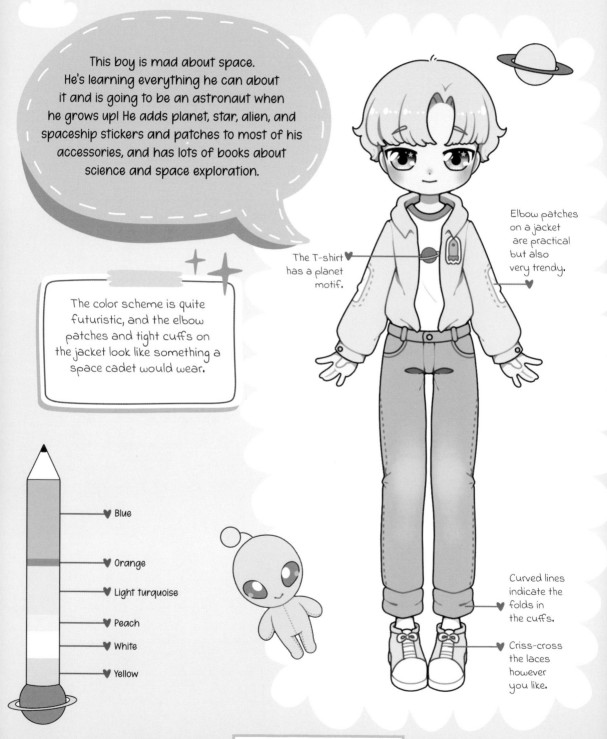

♥ Blue

♥ Orange

♥ Light turquoise

♥ Peach

♥ White

♥ Yellow

Curved lines indicate the folds in the cuffs.

Criss-cross the laces however you like.

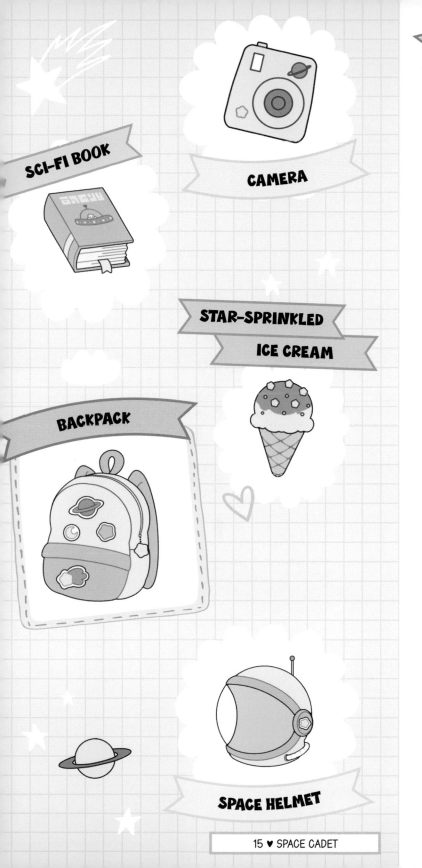

SCI-FI BOOK

CAMERA

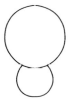

STAR-SPRINKLED
ICE CREAM

BACKPACK

SPACE HELMET

1. Draw a circle for the head and a smaller one for the body underneath.

2. Add big almond-shaped eyes and a tiny mouth. Draw in the arms and legs.

3. Let's add an antenna and the toy's stitches.

4. Green is a very popular color for aliens! This one also has a blue antenna and stitching.

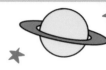

CREATE THE CHARACTER

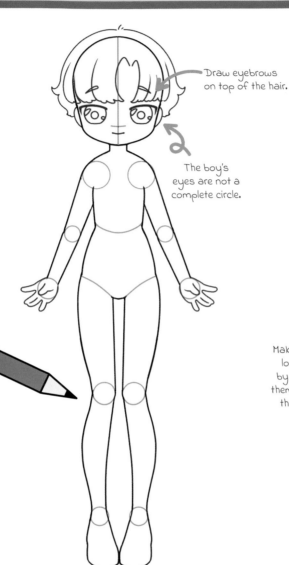

Draw eyebrows on top of the hair.

The boy's eyes are not a complete circle.

The puffy sleeves have a slightly tighter cuff.

Make clothes look tight by drawing them close to the body.

Add fold lines to show the jacket is tucked into the jeans.

1. Sketch a front view body, then add a short hairstyle, open hands, and the facial details. Note the shape of the eyes and the little dashes for eyebrows.

2. Let's do the outfit. Note that the jeans are tight at the waist and looser on the bottom. The jacket has puffy sleeves and a simple collar. Draw the sneakers now, too.

You can add a little pop of color on the T-shirt collar and the jacket badge.

Messy hair

Use a darker shade of the pants color for the pockets, folds, and stitches.

Rainbow hair

3. Add some space motifs to the jacket and T-shirt. Add pockets and stitches to the jeans, plus a few more lines in the hair, then you're ready to get coloring.

Parted bangs

ADD ACCESSORIES

BACKPACK

 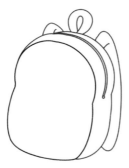 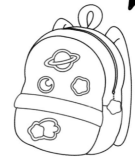 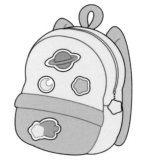

1. The backpack shape is a straight base and rounded over the top.

2. Make the backpack look 3D by drawing a shape similar to the first one, just behind it. Now add a zipper and the handles.

3. Add parallel lines for the bag's pocket, and space-themed patches on the front of the bag. Finish with a star pull at the end of the zipper.

4. Use the same blues as the character's jeans and jacket for the bag, then bring in yellow, purple, and red on the patches.

SPACE HELMET

 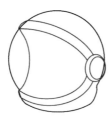 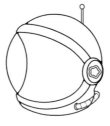 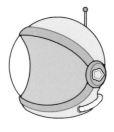

1. Start by drawing a circle, then add another line for the neck part of the helmet.

2. The bottom of the visor starts on the curve of the first circle. Add the upper part of the visor, which is hinged to the bottom part by a circle at the ear.

3. Add an antenna, an air tube on the neck piece, and a star on the visor hinge.

4. Color the helmet with light and dark blue, and add a touch of yellow for the star and red for the top of the antenna.

STAR-SPRINKLED ICE CREAM

1. Draw a cone with an ice-cream ball on top, and a wavy line where the ice cream overlaps the cone.

2. Add criss-cross details to the cone and star-shaped sprinkles on the ice cream.

3. Add color and more toppings if you like. This ice cream is bubble-gum flavor.

SCI-FI BOOK

1. Start by drawing a slanted rectangle—a parallelogram.

2. Draw parallel lines to the left and underneath, to show the book's spine and cover. Join the front and back covers with curved lines.

3. Add the details, including a space motif on the cover, lines to show the pages, and a ribbon bookmark.

4. Have fun coloring it in!

CAMERA

1. Start with a square shape that narrows a little at the top. Add three concentric circles.

2. Add the button on top and a rectangle for the flash. Let's add some cute space stickers, too!

3. Now add your colors.

BALLERINA DREAMER

With dreams of being a prima ballerina one day, this girl is always dancing. She likes to wear traditional puffy tutu dresses and her special pointe shoes, which allow her to dance on the tips of her toes. Her outfits always include lots of bows and frills, and even her favorite soft toy is based on a ballet character.

Ballet shoes are traditionally pink, and this character's color scheme builds on that by using three shades of pink, accented with white.

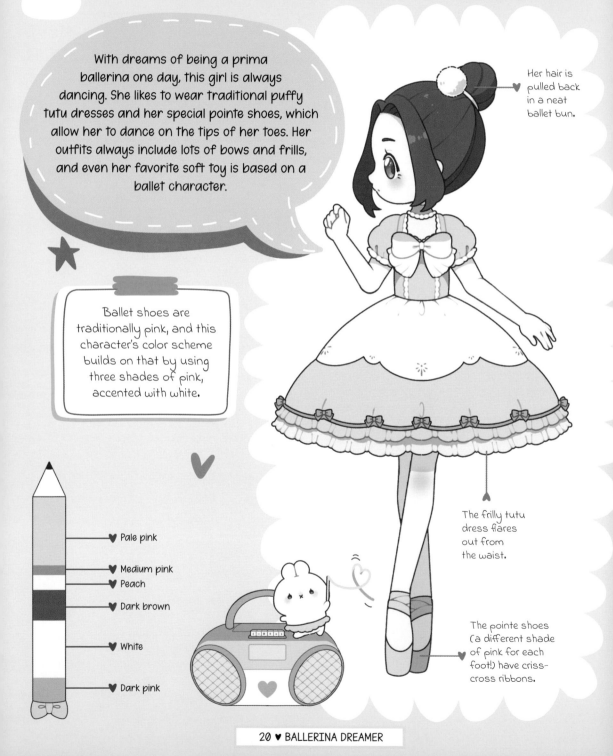

Her hair is pulled back in a neat ballet bun.

The frilly tutu dress flares out from the waist.

The pointe shoes (a different shade of pink for each foot!) have criss-cross ribbons.

♥ Pale pink

♥ Medium pink
♥ Peach

♥ Dark brown

♥ White

♥ Dark pink

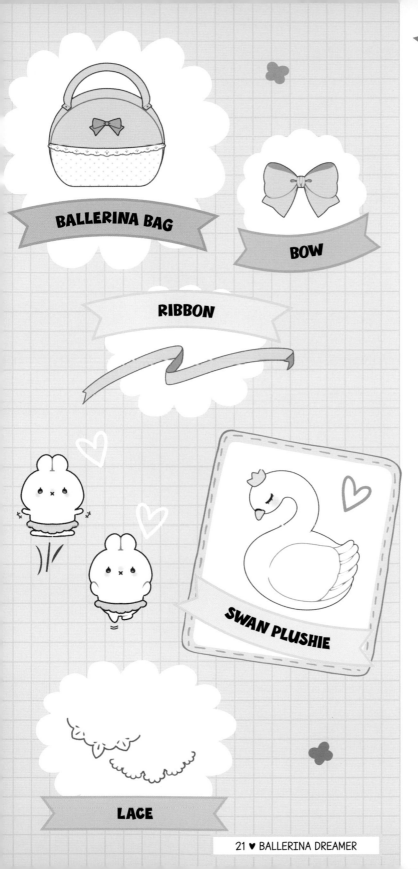

BALLERINA BAG

BOW

RIBBON

SWAN PLUSHIE

LACE

1. Start with a long rectangle shape with curved sides.

2. Add a line to separate the top and the front of the player. Add a round speaker made up of two ovals on each side.

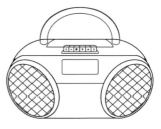

3. Add the buttons and handle on top, and a square to insert the CD into. Draw a rectangle on the front for the display panel and a grid pattern on the speakers.

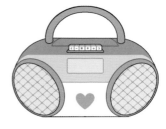

4. Color and add a cute heart.

CREATE THE CHARACTER

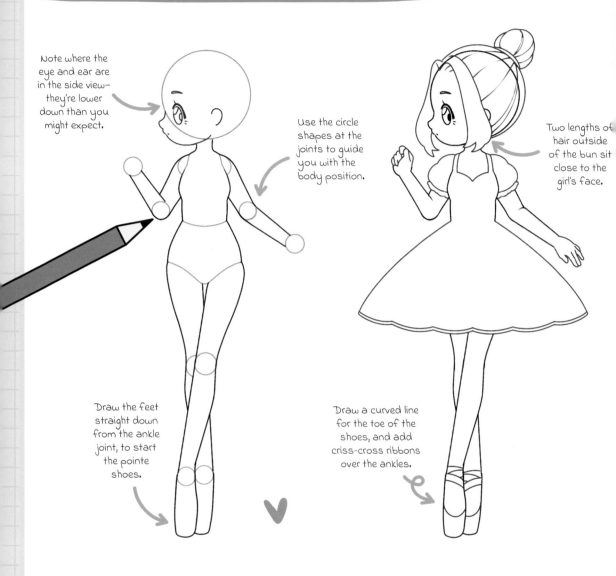

Note where the eye and ear are in the side view—they're lower down than you might expect.

Use the circle shapes at the joints to guide you with the body position.

Two lengths of hair outside of the bun sit close to the girl's face.

Draw the feet straight down from the ankle joint, to start the pointe shoes.

Draw a curved line for the toe of the shoes, and add criss-cross ribbons over the ankles.

1. Start the body in a front position, but make a dancing pose by positioning the arms and legs. Draw the nose, mouth, and chin at the side of the round head to give the profile view.

2. Draw the hair close to the head and add a ballet bun. Draw diagonal lines out from the girl's waist for the big skirt and join the two edges with parallel wavy lines. Add some poofy sleeves, shoes, and closed and open fingers.

The bodice of the dress is tight to the body, so you don't need to add any lines here.

First position

Back view

Ballet pose

See page 24 for alternative lace patterns.

3. Now to add the details, including bows, frilly skirt folds, and a pompom in the hair. When you start coloring, use a darker shade of pink under the first layer of the tutu skirt to show that there's a shadow where one layer of fabric is on top of the next.

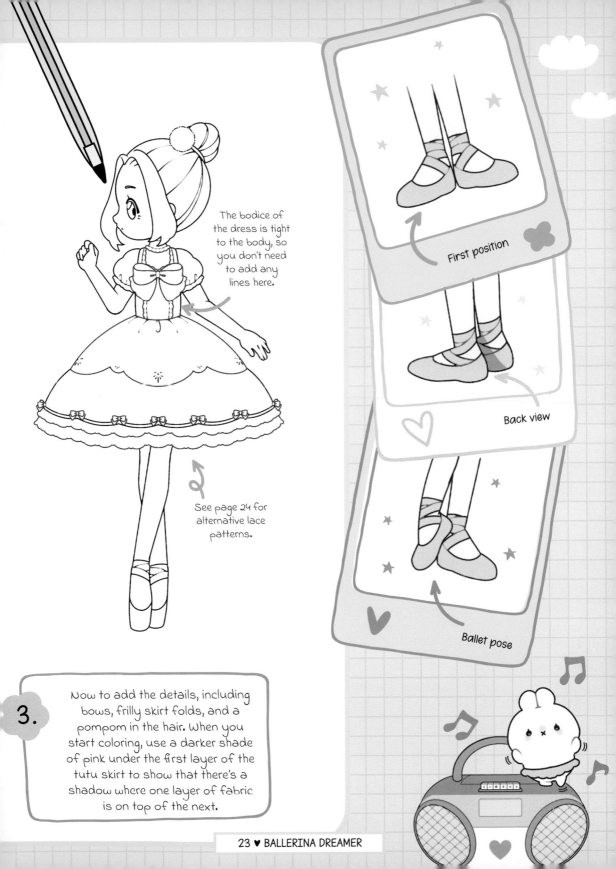

ADD ACCESSORIES

RIBBON

1. Start with a spaced-out wavy line.

2. Draw a similar line underneath the first one. See how the new line overlaps the first line?

 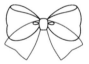 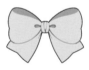

3. Connect the lines: use a little zigzag line for the ribbon edges.

4. When coloring, alternate colors to indicate the front and back sides of the ribbon.

BOW

1. Start with a small, slightly curved square for the center. Draw a curvy triangle shape on each side of the square, then add an oval shape above each triangle to make the bow look 3D. Add tiny folds in the centers.

2. Now draw the loose ends of the bow, which are similar in shape to the sides.

3. Color the folds and the inside of the bow in a darker shade.

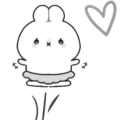

LACE PATTERNS

1. Start with a wavy line.

2. Add a little dot inside each round shape.

3. Go over your line and dots in your choice of color.

4. For variety, add smaller wavy lines to each round shape of the original wavy line, then erase the first line.

SWAN PLUSHIE

 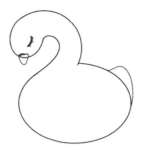 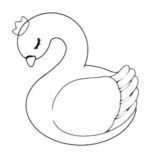 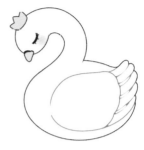

1. Draw a large oval for the body and a smaller oval for the head. Join the head and body with two long curved lines.

2. Add the beak, eye, and a little tail

3. Add a large wing with feathers at the end that overlap the tail. Don't forget to add a little crown!

4. Swans are usually white, but you can color the beak and add a little pink blush on the cheek!

BALLERINA BAG

1. Start by drawing a shape like three-quarters of a circle.

2. Add a curved line almost parallel to the top of the bag to give it depth. Add a curved handle on top of the bag.

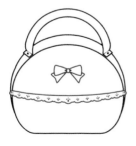 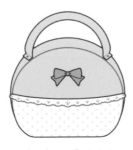

3. Add a bow and a lace frill (see page 24).

4. Use shades of pink to color the bag and add a dotty pattern if you wish.

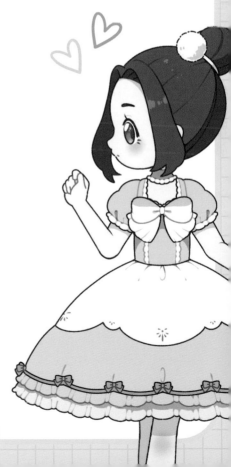

NURSE

This character is always busy, but she loves helping others, so sometimes she doesn't even notice how busy she is! She keeps a close eye on her patients to make sure they get their medicine on time and that they eat healthily to help them get better quickly.

This cross is a recognized symbol of the medical profession.

Shades of blue and white are traditional color schemes for nurse uniforms. The medical cross is usually colored red, but here the pink shade is softer and matches the character's hair.

The dress has long sleeves and a buttoned-up collar.

Heart-shaped pocket.

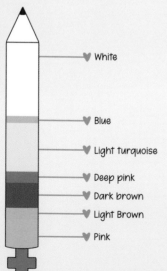

♥ White

♥ Blue

♥ Light turquoise

♥ Deep pink

♥ Dark brown

♥ Light Brown

♥ Pink

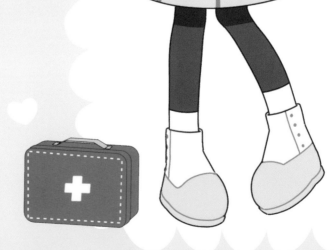

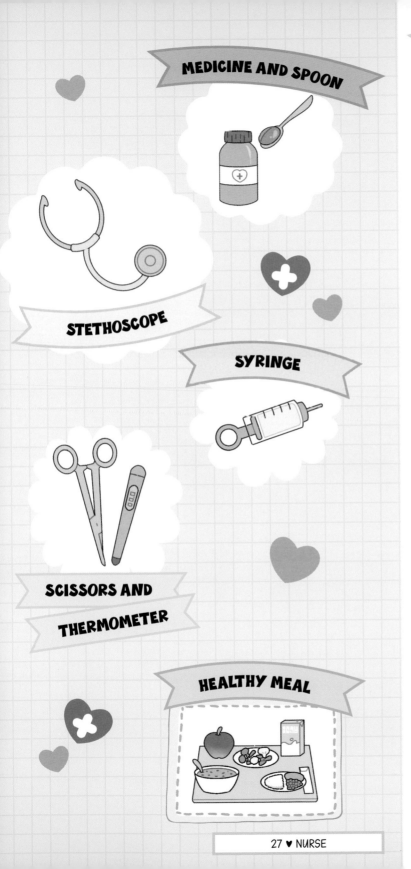

MEDICINE AND SPOON

STETHOSCOPE

SYRINGE

SCISSORS AND THERMOMETER

HEALTHY MEAL

FIRST AID KIT

1. Start with a rectangle at an angle and with curved corners. Echo the shape on the top and right-hand edges to make the kit look 3D.

2. Draw the handle on top and a line to show where the kit opens.

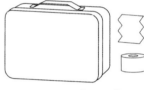

3. Draw a zigzag shape for a strip of bandaids, and a roll of bandage.

4. Draw the bandaids inside the strip, and a tail of bandage coming from the roll.

5. You can add stitching to the case as you color the kit.

CREATE THE CHARACTER

The hat is a simple shape.

You can draw the hand positions first, then add in the arms.

The hair curls under the chin.

Note the shape of the collar.

Draw a tilted rectangle for the notes.

This leg is bent out at the knee.

The skirt flares out from just above the waist.

Add a sock line and the tops of the boots.

Each foot is bent in at the ankle.

1. Draw the nurse holding her notes and a pen. She brings good news, so give her a happy face!

2. Draw the hair and hat, then add the long-sleeved dress, apron, and footwear. Add the hands: can you see that most of the hand holding the notes is not actually visible, only the curled fingers?

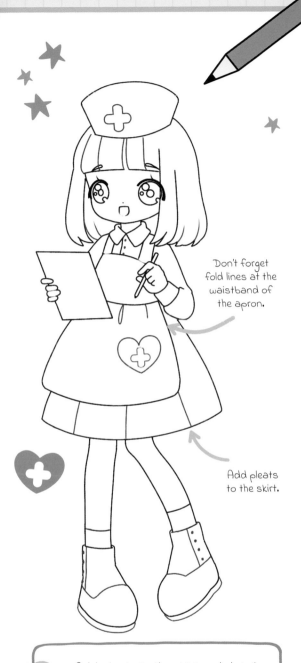

Don't forget fold lines at the waistband of the apron.

Add pleats to the skirt.

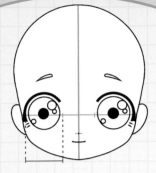

1. Start any face with a circle, then add shaping to the cheeks and chin.

2. Position the eyes below the center of the face. The space between each eye is the same size as an eye itself—so each eye takes up one-third of the width of the face. Add the eyebrows where the head shape begins to change. Alter the eyebrows to show emotion.

3. Draw the ears in line with the eyes, and the same height as the eyes. You can also vary your characters by giving them smaller or bigger ears, and placing the ears lower or higher than the usual eye line.

4. Place the nose and mouth below and between the eyes. You can change the size and shape of the mouth to create different expressions.

3. Add pleats to the skirt and details to the apron, boots, and hair. Add buttons under the collar, and medical crosses on the hat and pocket. When coloring, use a darker shade at the pleats to show that there are shadows there.

Worried

Confused

Angry

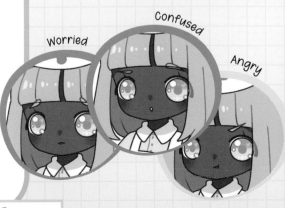

ADD ACCESSORIES

HEALTHY MEAL

1. Draw a tilted rectangle with an extra line parallel to the front edge to give depth.

2. Add an apple and a milk carton in the corners of the tray.

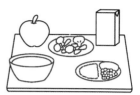

3. Add a bowl and plates of food, such as broccoli and carrots and rice, meat, and peas. You can draw any food you like—but don't forget to make it healthy!

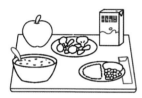

4. Draw the cutlery pack on the side, a spoon in the bowl, and some veg in the soup. Add the branding on the milk carton.

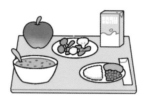

5. Color your food so that it looks full of nutrients.

SCISSORS AND THERMOMETER

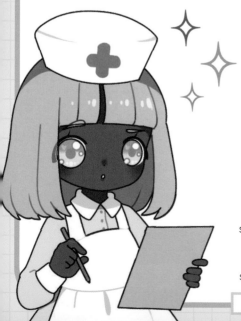

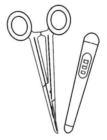

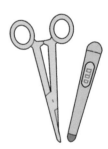

1. Draw two rings, one inside the other, for the scissor handles and diagonal lines to start the blades. Draw a tapered rectangle with curved edges to start the thermometer.

2. Draw the scissor blades around the diagonal lines. Draw an oval for the temperature scale and an oval for the lid.

3. Use different colors for the body of the thermometer and the temperature scale.

SYRINGE

1. Start with a rectangle, angled so that it's pointing diagonally.

2. Draw the needle on top, connected by a smaller piece.

3. Draw a ring and plunger. The syringe is transparent, so you can see the plunger inside!

4. Draw the liquid inside the syringe and add measurement lines.

5. Use different colors for the liquid inside the syringe and the plunger and needle.

MEDICINE AND SPOON

 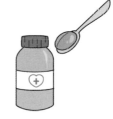

1. Start with a bottle shape and add a lid.

2. Draw parallel lines on the bottle for the label, and details on the lid.

3. Now draw an oval for the spoon and add its handle.

4. Draw some medicine on the spoon.

5. The medicine is colored but still transparent—so when you're coloring, make sure you can still see the spoon underneath!

STETHOSCOPE

 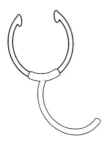 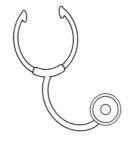 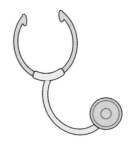

1. Draw a ring with an opening at the top, and earpiece shapes at each end.

2. Add the tube.

3. Draw concentric circles for the stethoscope's drum, at the end of the tube.

4. Color it all in.

MAID

She tries her hardest, but this maid can't help being clumsy. She is always on time, keeps her uniform clean, and ties her hair in a neat and tidy bun—yet there isn't a day that goes by that she doesn't trip over or bump into something, causing all kinds of havoc. Maybe she should consider a different career . . .

The uniform and shoes are very traditional in color and style for maids, but the green hair and glasses give this character her individuality.

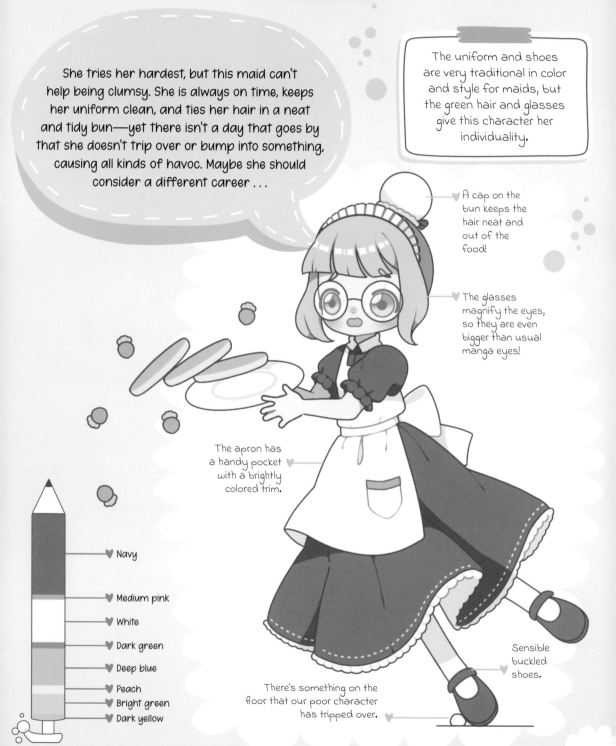

A cap on the bun keeps the hair neat and out of the food!

The glasses magnify the eyes, so they are even bigger than usual manga eyes!

The apron has a handy pocket with a brightly colored trim.

♥ Navy

♥ Medium pink

♥ White

♥ Dark green

♥ Deep blue

♥ Peach

♥ Bright green

♥ Dark yellow

There's something on the floor that our poor character has tripped over.

Sensible buckled shoes.

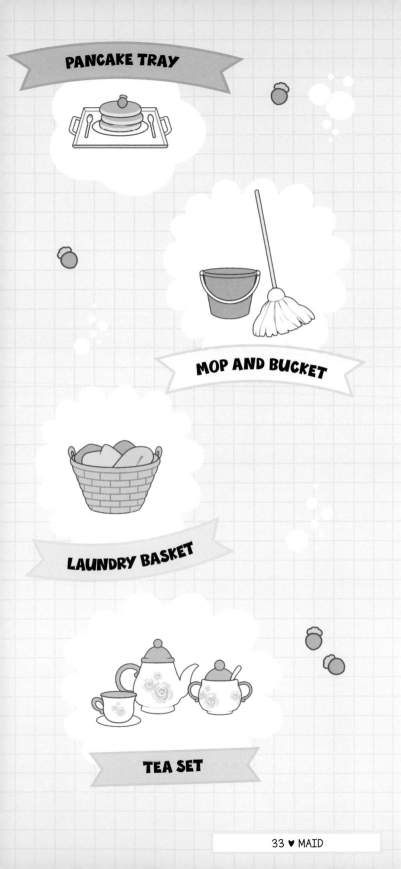

MOP AND BUCKET

LAUNDRY BASKET

TEA SET

1. Let's start with an oblong shape for the bottle of soap.

2. Now add the dispenser on top of the bottle and draw a small cube for the sponge.

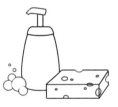

3. Draw different-sized circles for the bubbles. Add more circles to the sponge. Where the circles go over the edge of the sponge, erase the lines underneath so that the sponge looks holey.

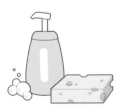

4. Color everything in and add highlights for shine.

CREATE THE CHARACTER

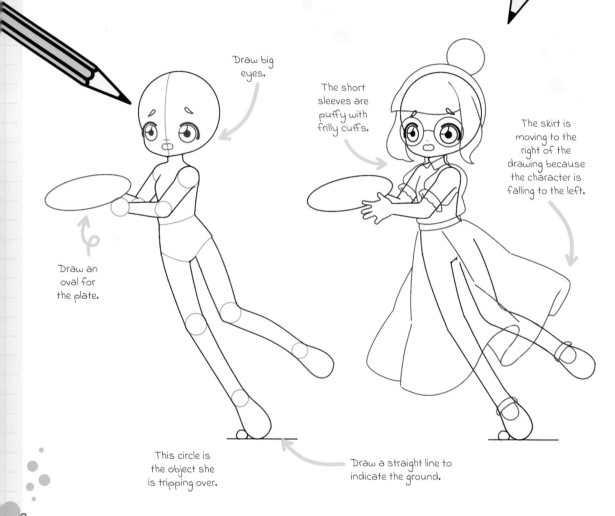

Draw big eyes.

The short sleeves are puffy with frilly cuffs.

The skirt is moving to the right of the drawing because the character is falling to the left.

Draw an oval for the plate.

This circle is the object she is tripping over.

Draw a straight line to indicate the ground.

1. Draw the maid's body at a slight diagonal angle, with one side of her foot on the floor and the other leg off the ground. Draw a circle on the ground next to the front foot. Add facial features and a plate for her to hold.

2. Draw some bangs and a neat bun at the back of the head. Add big round glasses around the eyes. Draw a short-sleeved dress with a floaty skirt that widens at the bottom, and the buckles on the shoes.

Add a frill to the cap on the bun, a neat headband, and detail lines on the bangs.

The strawberries are in midair and the pancakes are falling forward.

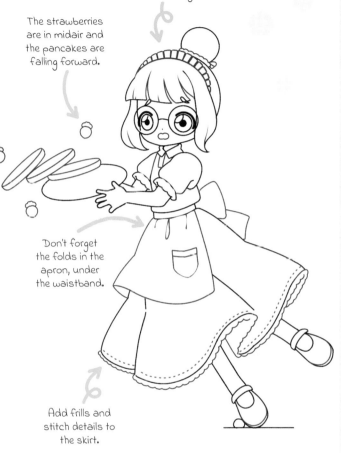

Don't forget the folds in the apron, under the waistband.

Add frills and stitch details to the skirt.

3. Add details to the clothes and hair, including the apron with its pocket and a bow tie at the back, and frills along the skirt. Add the pancakes and strawberries falling from the tray, and color your character.

DRAWING EYES

1. Start with a circle for the eyeball and a thick curved line over the top for the eyelid.

2. Draw an oval at top left for the highlight. Add eyelashes to the eyelid.

3. Pick a base color. Let's use light blue!

4. Draw the circular pupil and color it in a darker shade of blue.

5. On the upper part of the eyeball, gradually shade from dark blue to light.

6. Use a lighter color to dot in some highlights at the bottom of the eyeball.

7. Dot in a few more highlights at top right and bottom left. Draw short curved lines on either side of the pupil.

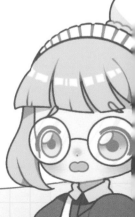

ADD ACCESSORIES

MOP AND BUCKET

1. Draw a curved line for the bottom of the bucket and a shallow oval for the top. Join the edges with straight lines.

2. Draw a long stick for the mop. Add a circle at the bottom and a wavy triangular shape under that. Add the bucket's handle and rim.

3. Add the details inside the outline of the mop.

4. Now for the coloring.

LAUNDRY BASKET

1. Draw a basket with a large top and smaller base.

2. Draw the handles on the side and a series of horizontal lines down the body of the basket.

3. Add little vertical lines between the horizontal lines in a brickwork pattern.

4. Draw wavy lines for the clothes in the basket.

5. You can use lots of different colors for the clothes.

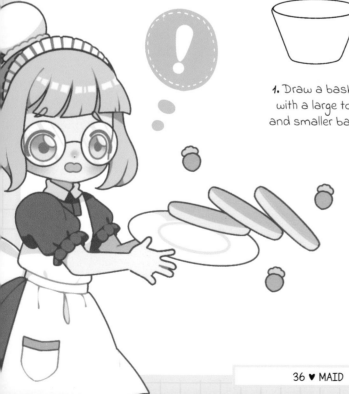

1. Start with a rectangular shape, with a longer horizontal line at the front than at the back.

2. Repeat the same shape under the base to give it more height. Add handles on the sides.

3. Draw a plate and cutlery.

4. Add a stack of pancakes with a strawberry on top.

5. Use a lighter color on the curved edges of the pancakes—this stops them from looking flat..

TEA SET

1. Start with a pear shape for the teapot. Add a line to show the lid position, with a circle knob on top. Add a base section.

2. Add the handle and spout, and curve off the edges of the lid.

3. Draw an oval for the top of the cup, then a curved shape under that. Add a handle.

4. Draw an oval shape under the cup for the saucer. Repeat the teapot steps, but smaller, to make the sugar bowl.

5. Add two handles to the sugar bowl and a spoon popping out.

6. You can add decorative motifs to your set as you color it.

WARRIOR PRINCE

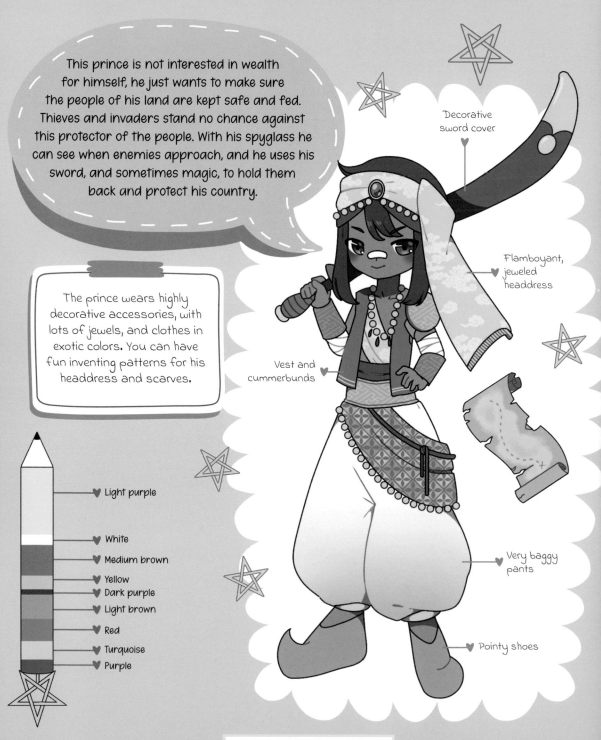

This prince is not interested in wealth for himself, he just wants to make sure the people of his land are kept safe and fed. Thieves and invaders stand no chance against this protector of the people. With his spyglass he can see when enemies approach, and he uses his sword, and sometimes magic, to hold them back and protect his country.

The prince wears highly decorative accessories, with lots of jewels, and clothes in exotic colors. You can have fun inventing patterns for his headdress and scarves.

Decorative sword cover

Flamboyant, jeweled headdress

Vest and cummerbunds

Very baggy pants

Pointy shoes

♥ Light purple
♥ White
♥ Medium brown
♥ Yellow
♥ Dark purple
♥ Light brown
♥ Red
♥ Turquoise
♥ Purple

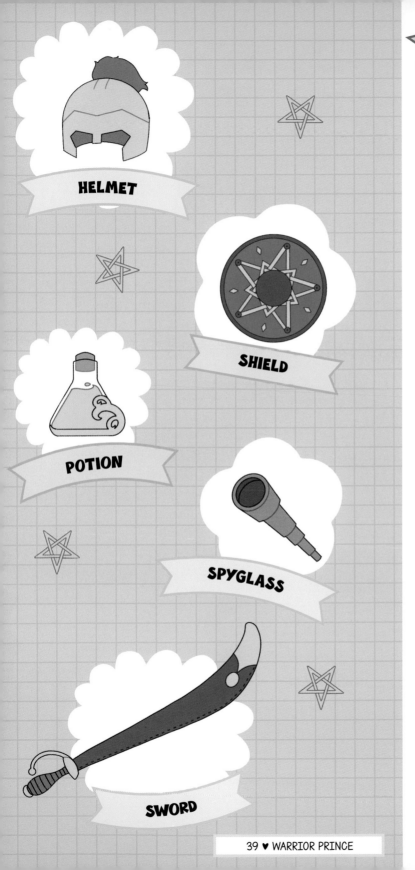

HELMET

SHIELD

POTION

SPYGLASS

SWORD

1. Draw two parallel curved lines and join them with vertical lines at each end.

2. Draw a spiral at each end and a roll on the right-hand edge.

3. Draw in some tears to make the map look old.

4. Have fun designing the map as you color it.

CREATE THE CHARACTER

Give the headdress a jewel at the center.

Draw a simple straight line for the sword at this stage.

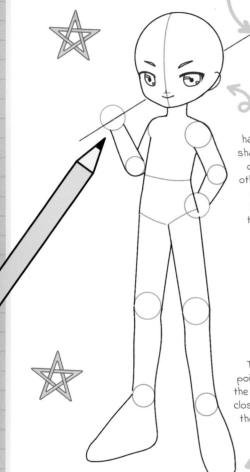

These eyes have a different shape than those of lots of the other characters, so there are instructions to draw them opposite.

The pants are really baggy around the calves.

This foot is pointing toward the viewer, and is closer to us than the other foot.

Draw two scarves draped over the hips.

The billowy pants come back in at the ankle.

1. Draw the character standing with one hand on his hip and the other holding the sword over his shoulder. Draw a line as a guide for the sword. Add the facial features.

2. Draw the hair and a big headdress around the front of the head and out to one side. Draw the vest, two cummerbunds at the waist, and big, billowy pants. Add the pointy shoes as well.

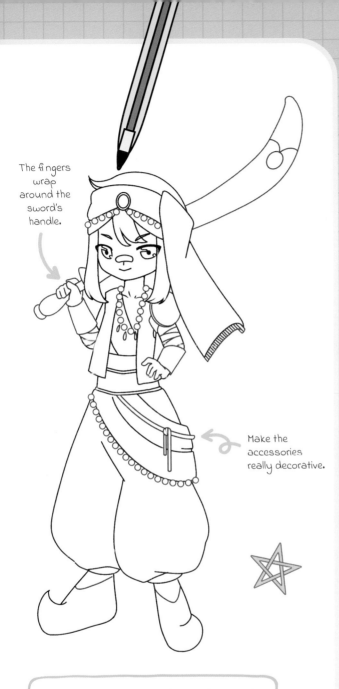

The fingers wrap around the sword's handle.

Make the accessories really decorative.

3. Draw the curved sword around the initial guideline that you drew in step 1. Draw the hands and lots of details on the clothes and accessories. You can also add more details and patterns as you color.

1. Instead of a full circle, draw a flat base for the eyeball and curved lines up to the angular eyelid.

2. Add the eyebrow and curved indents in the eyeball to act as the highlights.

3. Color the eyeball—we've gone for purple.

4. Add an oval, dark purple pupil with another oval line around it.

5. Add dark purple to the top of the eyeball; this shading makes the eye look rounded.

6. Add a brighter color, such as orange, at the bottom of the eyeball.

7. Dot in a white highlight at top right.

ADD ACCESSORIES

SPYGLASS

1. Draw a long, tapered cone, with a circle at the wider end.

2. Draw another circle around the first, and a series of curved lines down the body of the spyglass.

3. Straighten the edge lines for each section of the spyglass.

4. Color the glass section of the spyglass in a darker shade than the body.

POTION

1. Draw a triangle with a small rectangle at the top.

2. Draw a cork in the opening and add some decorations to the bottle.

3. Add the liquid inside.

4. Make the potion a bright color.

HELMET

1. Start with a circle.

2. Straighten the bottom of the circle and add a square opening in the center.

3. Give the opening an interesting shape, such as a long nose section and wide holes for the eyes.

4. Add details such as a hair tuft on top.

5. Color the helmet, making it darker on the inside.

1. Start by drawing a ring—a circle within a circle.

2. Add another circle in the center of the shield. Divide the circle into five and draw an ornament in each section.

3. Draw a star and other decorations.

4. Use bold colors for your design.

SWORD

1. Draw a handle for the sword and a long curved blade. This type of sword is called a scimitar!

2. Add details to the handle and a hand protector.

3. Add details to the blade shape—this is now the blade's cover.

4. Use the same colors for your sword as you did for the shield.

STRAWBERRIES AND CREAM

This girl loves picking strawberries for picnics in the park or garden, and her favorite way to serve them is with cream. She wears an apron so she doesn't get stains on her dress, and a cute strawberry hair clip in her hijab. She loves hearing the birds sing when she's out, as well as drawing and writing about wildlife in her journal.

This color scheme is inspired by strawberries and cream, with the white apron and trim at the bottom of the dress breaking up the pinks and the plaid pattern. Without this, the outfit would look too fussy.

Peach

Light green

Pale pink

White

Dark pink

Brown

Pink

Deep pink

Light brown

Lines and shading on the hijab show how it drapes.

The apron is tied at the back with a bow.

The basket is partially hidden behind the skirt.

The slip-on shoes have a strawberry decoration.

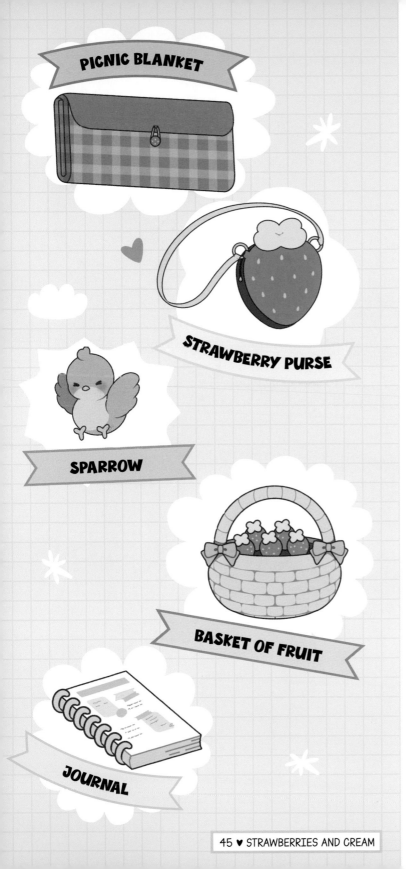

PICNIC BLANKET

STRAWBERRY PURSE

SPARROW

BASKET OF FRUIT

JOURNAL

You can change your character's hand shapes (see page 47).

1. Start with the usual circle for the hand.

2. Draw a small circle inside the big circle, at the bottom left, for the base of the thumb. Draw a cut-off oval for the top of the thumb and two fingers up from the top of the big circle. Draw the outline of the two folded-down fingers.

3. Erase the guidelines and add a line to separate the pinky and the ring finger.

4. When coloring, note where the darker shade is used to give the 3D effect.

CREATE THE CHARACTER

Note where the guideline showing the center of the face is when the head is slightly turned to one side.

The hijab is tight on top of the head, but loose and long around the chin and in front of the shoulders.

This eye is drawn smaller than the other one to make it look farther away from the viewer. We call this "perspective."

Draw her nose and mouth pointing toward the side she is facing.

Curve the puffy sleeves so that they tuck into the cuffs.

This hand is ready to hold the basket.

Draw a long, wavy line at the bottom of the floaty skirt.

1. Draw the girl's upper body so that it faces slightly away from the viewer, and give the arms and legs a natural pose. Take care over where you position the facial features. Draw open fingers on one hand and lightly closed fingers on the other one.

2. Give her a long dress with poofy sleeves and a flowing skirt. A simple curved line indicates each shoe. Let's add her hijab as well.

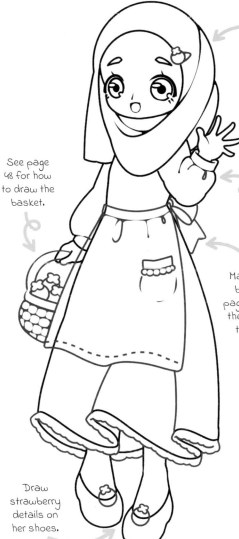

Add a strawberry hair clip.

See page 48 for how to draw the basket.

Add little pleat lines on the apron and sleeve.

Make a half bow (see page 24) to tie the apron at the back.

Draw strawberry details on her shoes.

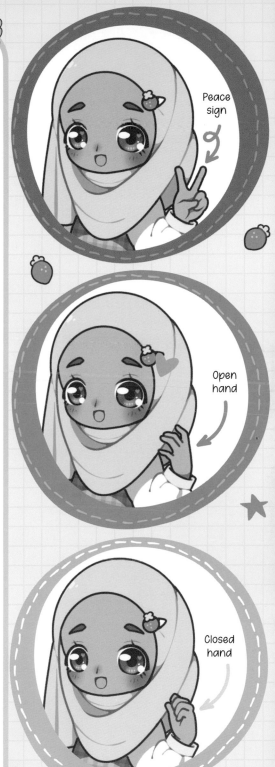

Peace sign

Open hand

Closed hand

3. Draw an apron with a pocket and stitches along the bottom edge. Add folds and frills to the clothes and cute strawberry details. Give her a basket to hold and get coloring. Don't forget to give her dress a plaid pattern.

ADD ACCESSORIES

BASKET OF FRUIT

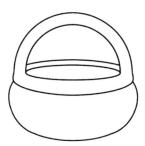

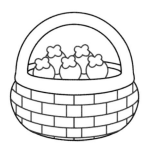

1. Start by drawing the body of the basket. Use parallel curved lines for the rim and handle. Notice that the parallel lines for the rim are closer together on the side of the basket that's farther away from you.

2. The strawberries inside the basket are a simple oval shape with a little cross on top. Draw a pattern of squares and rectangles on the body of the basket to give the rattan texture.

3. Add two bows and the handle details.

4. When coloring, add some yellow dots for the strawberry seeds.

STRAWBERRY PURSE

1. Start with a basic strawberry shape.

2. To make the purse look 3D, draw a line that follows the shape of the base, from bottom left to near top right. Add a zipper.

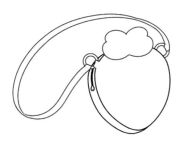

3. Draw a long handle with circular end pieces. Add a cloud shape on top of the purse.

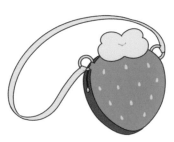

4. Color the cloud shape green and use pinks for the rest of the purse. Don't forget to add yellow seeds!

1. Start by drawing a slanted rectangle—a parallelogram.

2. Draw parallel lines for the spine and back cover. Join the front and back covers with curved lines.

3. Draw a few lines for the pages of the journal, then add rings down the spine.

3. The coloring is really fun because now you can create a page in the journal.

PICNIC BLANKET

1. Draw a rectangle with curved corners, with a long oval at the left edge.

2. Draw another long oval inside the first one. Draw a straight line curving up at each end across the front of the blanket, and add a strawberry button.

3. Gingham is a classic picnic blanket pattern.

SPARROW

1. Start with a circle for the head and a lemon shape for the body, overlapping the circle.

2. At the left of the head add a little curve in and out to give the sparrow a cheek. Add eyes, a beak, and a little tuft of feathers on top of the head.

3. Add "Y" shapes for feet, and draw the wings. Note that the upper part of the wing is bigger than the bottom part.

4. To draw other types of birds, use different color combinations.

LATE FOR SCHOOL

Late again! It's breakfast on the go for this schoolgirl. Thankfully, her satchel contains everything she needs for a day of learning, and she should be just in time to catch the school bus.

Japanese school uniforms are often modelled on European naval uniforms, just like this one. Sensible shoes and knee-high socks complete the look. ♥

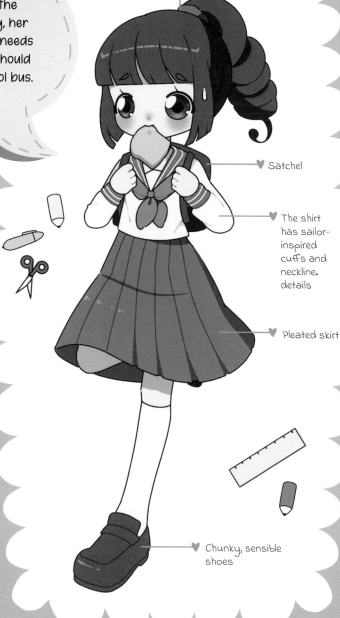

A neat pigtail is perfect for school.

♥ Satchel

♥ The shirt has sailor-inspired cuffs and neckline. details

♥ Pleated skirt

♥ Chunky, sensible shoes

♥ Dark brown

♥ Beige

♥ Indigo

♥ White
♥ Red

♥ Peach

SPORTS BAG AND SNEAKERS

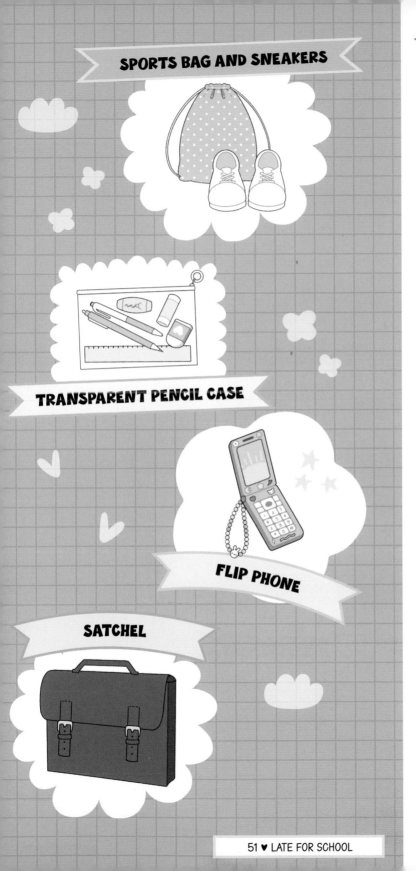

TRANSPARENT PENCIL CASE

FLIP PHONE

SATCHEL

1. Draw a rectangle on a slant and add other rectangles bottom and right to make it look 3D.

2. Split the box into three compartments.

3. Add your food! Draw rice and sliced meat in the larger compartment, and apple slices and salad in the other sections.

3. Color the box and the food.

CREATE THE CHARACTER

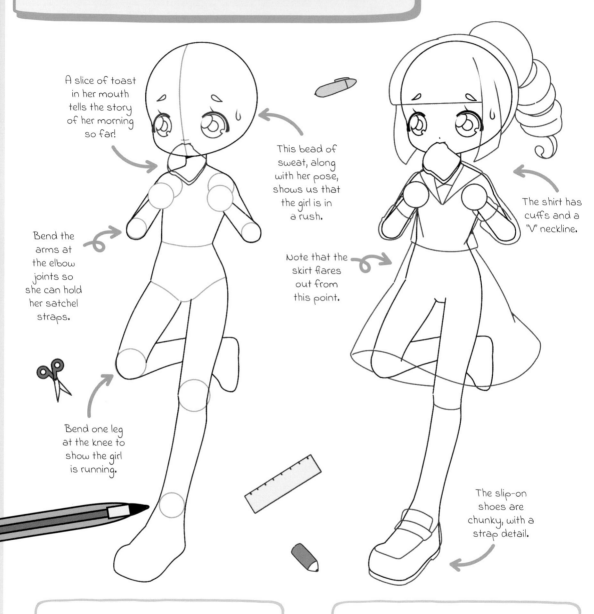

A slice of toast in her mouth tells the story of her morning so far!

This bead of sweat, along with her pose, shows us that the girl is in a rush.

Bend the arms at the elbow joints so she can hold her satchel straps.

Note that the skirt flares out from this point.

The shirt has cuffs and a "V" neckline.

Bend one leg at the knee to show the girl is running.

The slip-on shoes are chunky, with a strap detail.

1. Start with a running pose, with her hands near the shoulders where she is holding her satchel. Add the facial features and a slice of toast where her mouth should be.

2. Draw a curly pigtail and bangs. Add a long-sleeved shirt with a "V" neckline and a knee-length skirt that flares out toward the bottom. Draw the shoes and a simple line for the top of the sock.

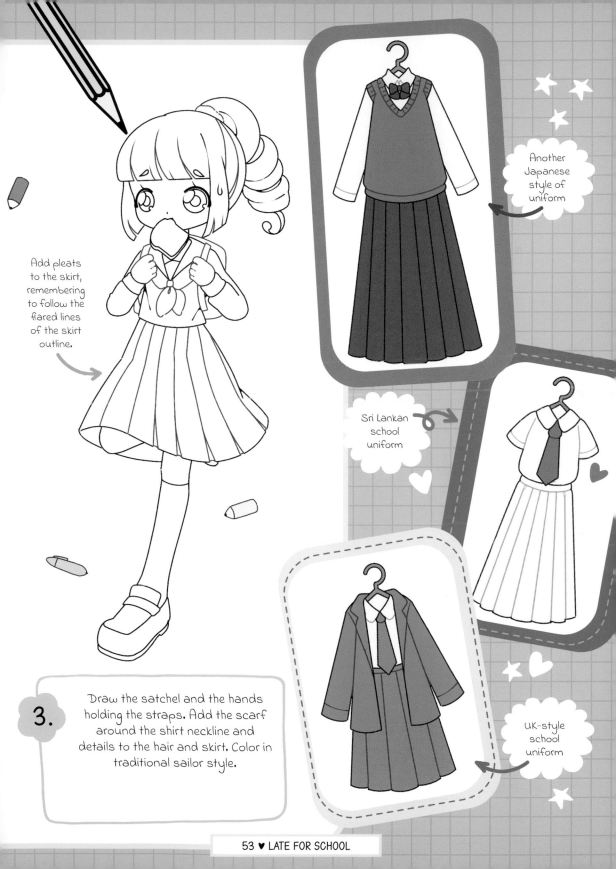

Add pleats
to the skirt,
remembering
to follow the
flared lines
of the skirt
outline.

Another
Japanese
style of
uniform

Sri Lankan
school
uniform

UK-style
school
uniform

3. Draw the satchel and the hands
holding the straps. Add the scarf
around the shirt neckline and
details to the hair and skirt. Color in
traditional sailor style.

ADD ACCESSORIES

SATCHEL

1. Start with a rectangle at an angle to the viewer.

2. Draw a thin rectangle at the right edge to make the satchel look 3D and add a flap on top.

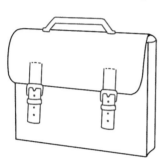

3. Draw the handle and the two straps and buckles that close the flap.

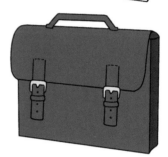

4. Color the buckles in a lighter shade than the rest of the satchel.

FLIP PHONE

 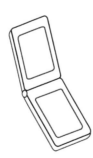

1. Start with two connected rectangles.

2. Extra lines on the side and bottom edges make the phone look 3D. Add two more rectangles inside the first two.

3. Add details. The top rectangle is the screen and the bottom features the buttons.

4. Add cute stickers on the phone and a charm on the side.

5. When coloring, add a cool screen saver.

SPORTS BAG AND SNEAKERS

1. Draw an organic shape for the bag, making it wider at the bottom. Add straps on either side of the bag and little lines at the top to show where the bag is drawn closed.

2. The shape for the sneakers is similar to that of the bag— smaller on top and larger at the bottom.

3. Add the opening and the laces to the sneakers.

4. Add a pattern to the bag as you color it.

TRANSPARENT PENCIL CASE

1. Start by drawing a rectangle. Add a thin rectangle on top for the zipper, and a circular zipper pull.

2. Add the stationery, such as a mechanical pencil, pen, ruler, eraser, marker, and glue stick.

3. Color the case contents.

JAPANESE PRINCESS

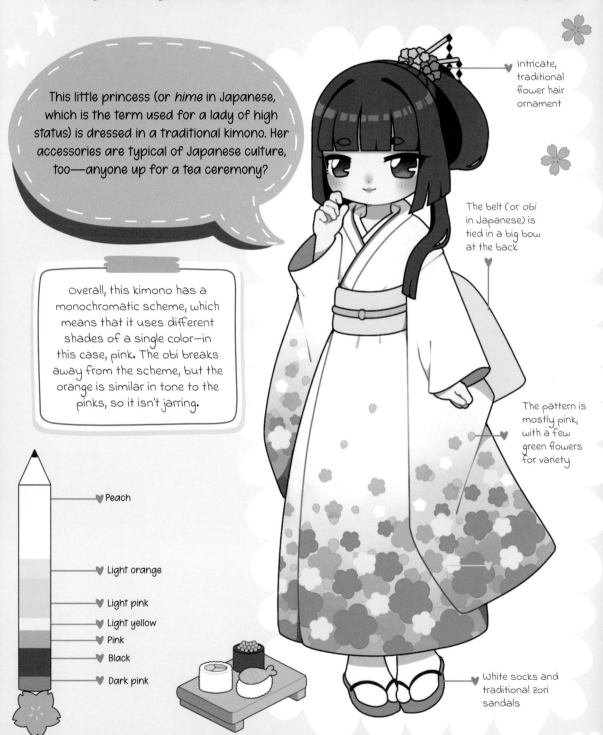

This little princess (or *hime* in Japanese, which is the term used for a lady of high status) is dressed in a traditional kimono. Her accessories are typical of Japanese culture, too—anyone up for a tea ceremony?

Overall, this kimono has a monochromatic scheme, which means that it uses different shades of a single color—in this case, pink. The obi breaks away from the scheme, but the orange is similar in tone to the pinks, so it isn't jarring.

Intricate, traditional flower hair ornament

The belt (or obi in Japanese) is tied in a big bow at the back

The pattern is mostly pink, with a few green flowers for variety

White socks and traditional zori sandals

♥ Peach

♥ Light orange

♥ Light pink

♥ Light yellow

♥ Pink

♥ Black

♥ Dark pink

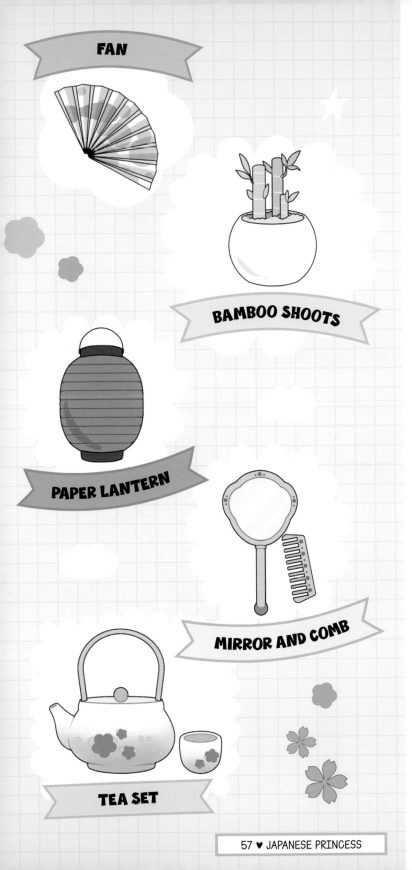

FAN

BAMBOO SHOOTS

PAPER LANTERN

MIRROR AND COMB

TEA SET

1. A sushi board is usually made of bamboo or wood to keep the sushi fresh! Draw a slanted rectangle and two lines parallel to and below the left and front lines. Connect the lines at the edges of the board, then draw new rectangles for the legs.

2. Now let's add the sushi. Draw two sushi rolls and an ebi (rice with shrimp on top).

3. Add the fillings to your sushi rolls.

4. Add color to the board and the sushi. The roll with noki has rice on the outside, while the roll with roe has seaweed wrapped around it.

CREATE THE CHARACTER

This eye is not as wide as the other eye, because it is facing slightly away from the viewer.

Note that the eyes are not complete circles.

Curve the face in a little under this eye.

Draw wide sleeves on the kimono.

The obi sits above the waist.

The knees are together, with one leg bent slightly outward.

Note the position of the feet.

1. This character has a graceful pose, and is facing away from the viewer just a little. Add the fingers and facial details, taking note of the eye shape.

2. Add the hair, giving her straight bangs, a big updo at the back, and a length of loose hair on one side. Draw a long-sleeved kimono and the start of the obi below the chest. Now draw the sandals.

You can still see the eyebrows, even though they are under the bangs.

Add flowers to the hair ornament.

The obijime cord wraps around the obi.

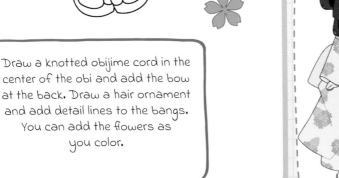

3. Draw a knotted obijime cord in the center of the obi and add the bow at the back. Draw a hair ornament and add detail lines to the bangs. You can add the flowers as you color.

COLOR THEORY

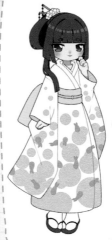

COMPLEMENTARY
This combination is based on using two colors that are opposite each other on the color wheel. Let's start with a blue kimono; the opposite of blue is orange, so let's work with this match!

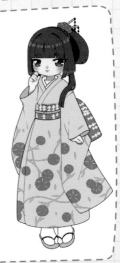

TRIADIC
This combination is based on a color and two evenly separated colors - you should be able to make a triangle with two equal sides! Let's start with yellow and pick two evenly separated colors—green and a bold orange.

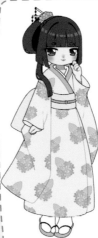

ANALOGOUS
This combination is created by three colors in a row. Let's pick a blue again and see how this combination will turn out compared to the complementary match. The two colors on either side are light blue and purple.

ADD ACCESSORIES

TEA SET

1. Draw a wide bulbous shape for the body of the teapot, with an elongated oval on top and a rim at the bottom. Draw a curved little cup.

2. Add a tall curved handle, a spout, and a circle on top of the lid.

3. Use the same colors and flower motifs on the teapot and cup as you did on the kimono.

BAMBOO SHOOTS

1. Draw a round shape with a flat base and an oval on top.

2. Add three canes of bamboo, all different sizes.

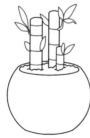
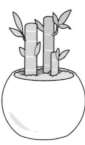

3. Draw a few horizontal lines on each cane, and add arrangements of leaves.

4. Get coloring! A curve of pink shading on the pot gives it a 3D, rounded feel.

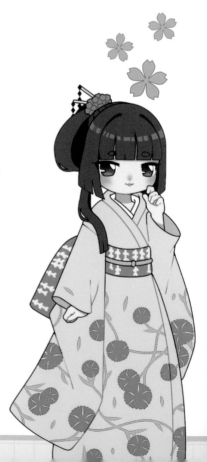

FAN

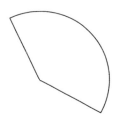

1. To make this shape, draw a circle and divide it into thirds (it doesn't have to be perfect). Erase two of them.

2. Draw evenly spaced pairs of straight lines that fan out from the center of the shape to the curved edge.

3. In between each pair of lines draw another straight line that extends just over the curved edge of the fan. Top each of these lines with a tiny triangle.

4. Use a single color between the paired lines to indicate the bamboo spines of the fan. Use a highlight color to the left of each of the lines made in Step 3, to give the 3D effect.

MIRROR AND COMB

1. Draw a slanted rectangle to start the comb. Draw a pleasing, even shape for the mirror, then add a thin rectangle as a handle.

2. Echo the mirror outline inside the original shape. Draw the prongs of the comb and add details to the mirror handle.

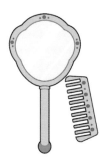

3. Include bright diagonal highlights when you color the mirror, which will make it look reflective.

PAPER LANTERN

1. Paper lanterns have a bamboo frame. Draw a long oval shape that flattens out at the top and bottom. Add little rectangles.

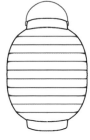

2. Add a curved line for the handle and horizontal lines to indicate the paper folds.

3. Red is the color most often used for these lanterns.

SWEET LOLITA

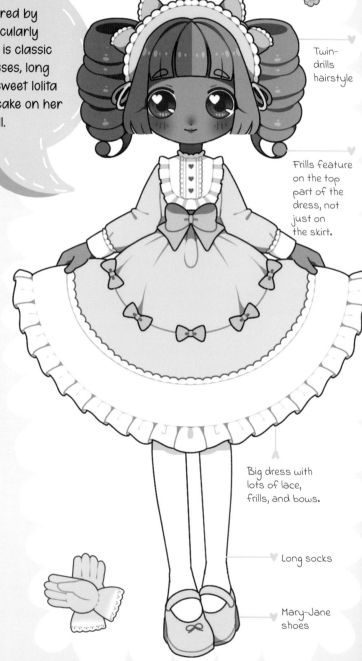

Lolita fashion in Japan is inspired by historical Western styles, particularly from the Victorian era. The style is classic and doll-like, with big poofy dresses, long sleeves, and elaborate frills. This sweet lolita loves shopping, and stopping for cake on her way home from the mall.

The sweet lolita scheme is based around candy colors and frills. For a classic loilita style use dusty or jewel tones; for Gothic lolita use blacks and purples.

Twin-drills hairstyle

Frills feature on the top part of the dress, not just on the skirt.

Big dress with lots of lace, frills, and bows.

Long socks

Mary-Jane shoes

♥ White

♥ Pale brown

♥ Light blue

♥ Deep pink
♥ Pink

♥ Dark brown

♥ Medium pink

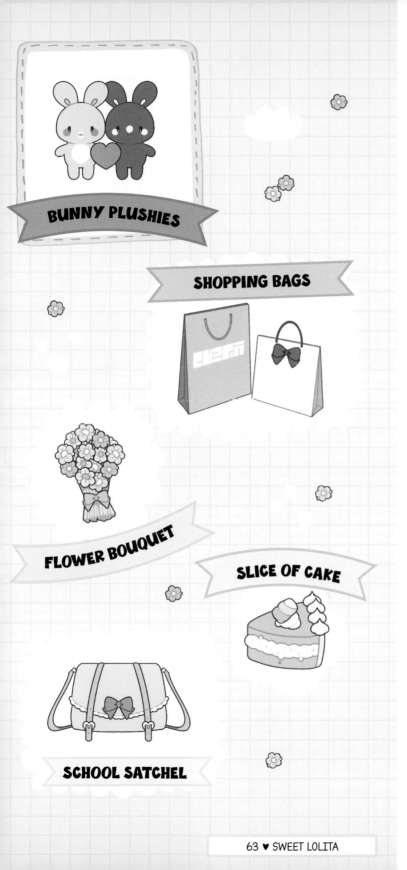

BUNNY PLUSHIES

SHOPPING BAGS

FLOWER BOUQUET

SLICE OF CAKE

SCHOOL SATCHEL

1. When a lolita girl wears gloves, they have to be fancy. Start by drawing a hand.

2. Add a sleeve curving out from the wrist. Give it frills along the bottom.

3. Now add a second glove, tucked behind the first one in a cross shape.

4. Color the gloves to match your lolita's outfit.

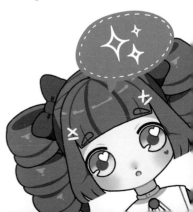

CREATE THE CHARACTER

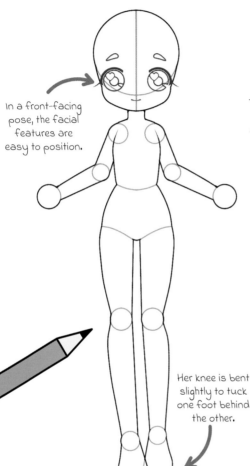

In a front-facing pose, the facial features are easy to position.

Twin drills are pigtails that are tightly curled

The sleeves are slightly baggy, and the skirt is very big.

Use lots of curved lines to show the drill curls.

Her knee is bent slightly to tuck one foot behind the other.

1. Draw a front-facing figure with arms bent at the elbows. Tuck one foot slightly behind the other and bend that knee.

2. Give her straight bangs and curly twin drills. Draw three concentric semicircles for the skirt and add the fingers that hold it. Draw curved lines for the shoes, and add a strap. There's also a bow on her dress and two in her hair.

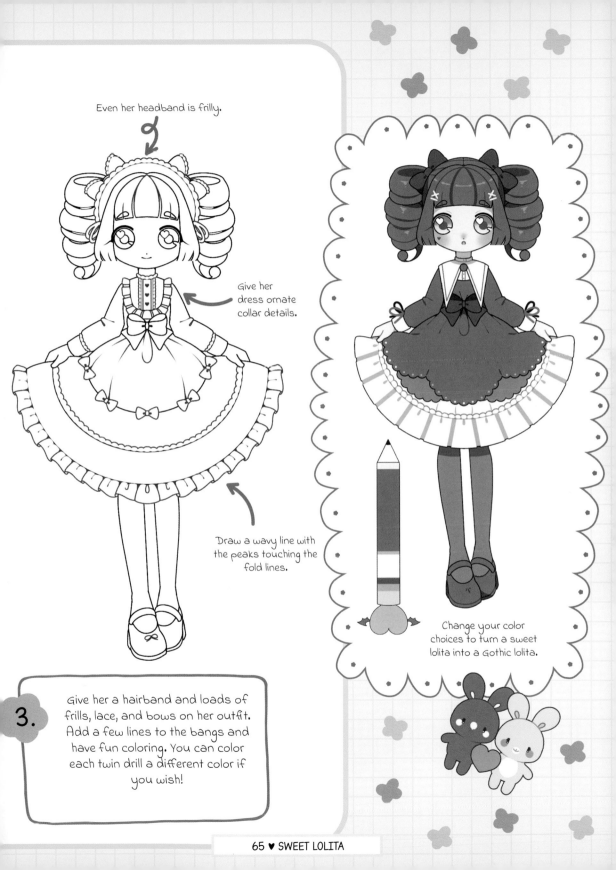

Even her headband is frilly.

Give her dress ornate collar details.

Draw a wavy line with the peaks touching the fold lines.

Change your color choices to turn a sweet lolita into a Gothic lolita.

3. Give her a hairband and loads of frills, lace, and bows on her outfit. Add a few lines to the bangs and have fun coloring. You can color each twin drill a different color if you wish!

ADD ACCESSORIES

SHOPPING BAGS

1. Draw two slanted rectangles to start the bags.

2. Draw tirangles for the sides of the bags.

3. Add curved lines for bag handles, up or down, and decorative details.

4. You can use the colors and logos of your favorite brands on your bags.

1. Our sweet lolita loves pretty things, like bouquets of flowers. Draw little flowers side by side to make a rough circle shape.

2. Fill the inside of the circle with more flowers!

3. Draw the stems and hold them together with a cute bow.

4. Don't forget to make the stems green.

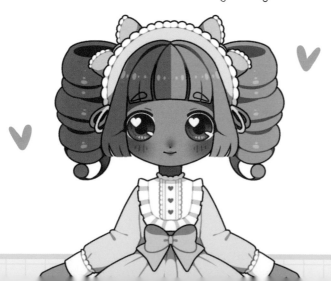

BUNNY PLUSHIES

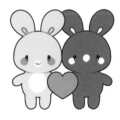

1. Sweet plushies for our sweet lolita. Start with round heads and tiny bodies and legs.

2. Add bunny ears and little arms.

3. Add cute faces and a heart between the bunnies.

4. When you color them, you can give your bunnies different characteristics.

SCHOOL SATCHEL

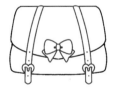

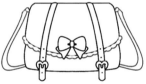

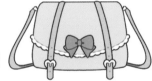

1. Start with an envelope shape that is wider at the bottom than at the top.

2. Add a bow and two straps and buckles.

3. Add a lace frill and a long strap.

4. Color the satchel to match your lolita's dress.

SLICE OF CAKE

1. Start with a curved triangle.

2. Draw straight lines down from each side of the slice and join them with a line that echoes the first triangle.

3. Let's add cream filling and some cream and decorations on top!

4. You can add sprinkles to the cream when you start coloring.

MYTHICAL MERMAID

This mermaid has found many treasures under the sea to use for decoration, and there are many sea creatures for her to make friends with, too.

A watery blue and lilac color scheme is a natural choice for a mermaid; here, it's been given a twist with a pink and orange tail.

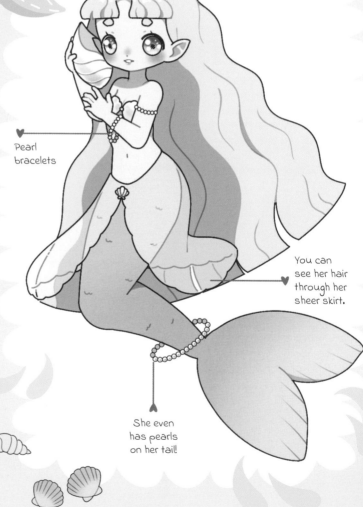

Pearl headdress

Pearl bracelets

You can see her hair through her sheer skirt.

She even has pearls on her tail!

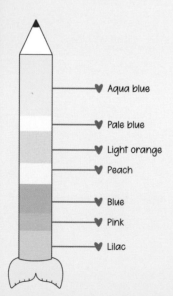

Aqua blue

Pale blue

Light orange

Peach

Blue

Pink

Lilac

SEA TURTLE

SHIP IN A BOTTLE

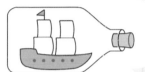

SEAHORSE

SEASHELLS

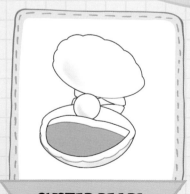

OYSTER PEARL

1. Start with a half circle.

2. Draw a line to make the helix.

3. Color the ear! The inner ear should be in darker colors to show that this area is in shadow.

POINTY EARS

Now that you know how to draw a human ear, you can modify the helix (that's the bit at the top) for fantasy creatures like mermaids, elves, and fairies (page 80).

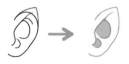

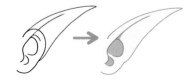

CREATE THE CHARACTER

Draw a pointed almond shape for the conch shell.

Start with a usual ear shape.

Like the sea, her hair is wavy, even the bangs.

Now you can add the point to the ears.

Bend the arms so that the mermaid can hold her shell.

Don't forget the hair on this side!

The joints for a tail are the same as for legs, but there's only one joint instead of two.

1. The mermaid's tail is the same size and has the same joints as legs. Use the circle guidelines to draw the tail position. The fin, from the ankle, is much bigger than feet would be. Draw facial features and a shell by the character's ear.

2. Draw long, wavy lines down almost to the fin for the mermaid's hair. Draw a curved line along the bottom to complete the shape of the hair. Add the fingers and bikini top, and give the ears a pointed tip.

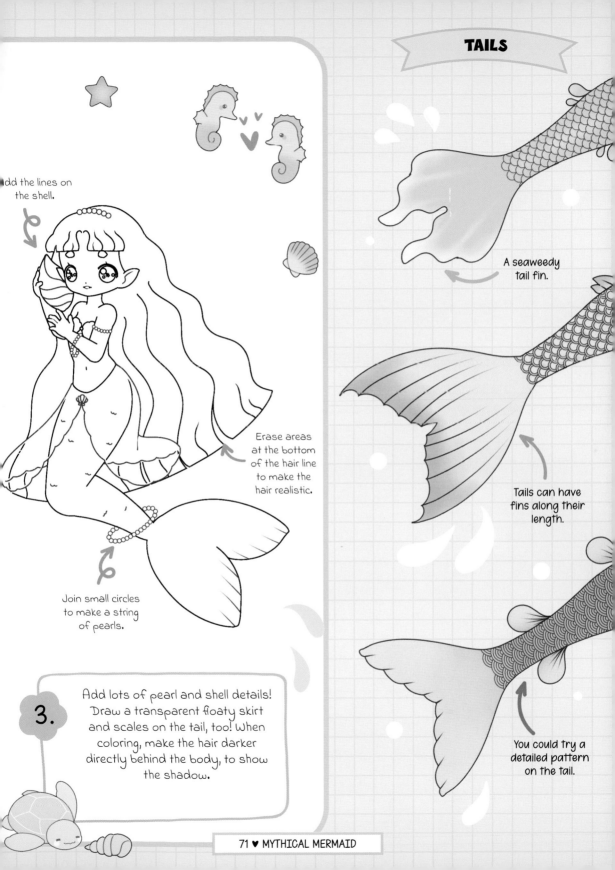

Add the lines on the shell.

A seaweedy tail fin.

Erase areas at the bottom of the hair line to make the hair realistic.

Tails can have fins along their length.

Join small circles to make a string of pearls.

3. Add lots of pearl and shell details! Draw a transparent floaty skirt and scales on the tail, too! When coloring, make the hair darker directly behind the body, to show the shadow.

You could try a detailed pattern on the tail.

ADD ACCESSORIES

SHIP IN A BOTTLE

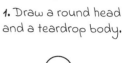

1. Start with a simple ship's base shape, and add the portholes.

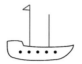

2. Draw the masts and add a flag on the bigger one.

3. Use the masts as guidelines for the sails.

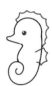

1. Draw a round head and a teardrop body.

2. Add the snout and a curly tail.

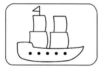

4. Draw a rectangle framing the ship.

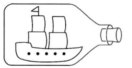

5. Narrow the neck of the bottle and add a cork.

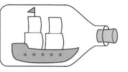

6. Color the boat and cork.

3. Add the eyes, fins, and the coronet.

4. Get coloring.

SEA TURTLE

1. Draw a big oval shape for the shell and a smaller oval for the head.

2. Draw the flippers. The front flippers are more visible. Draw only the tips for the back flippers.

3. Draw the face and the details on the shell—note how the shell is made up of hexagons.

4 Color in the turtle, using a dark green for the shell and pink for the cheeks.

OYSTER PEARL

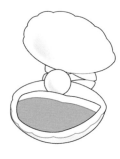

1. Start with a shell outline.

2. Add another shell on the bottom, hinged to the first shell.

3. Add a circle for the pearl and a curved line to give depth to the lower shell.

4. Add the blanket.

5. Use blue graded shading on parts of the shell, and make the blanket pink.

SEASHELLS

1. Start with a fan-shaped outline for a shell!

2. Add the shell details and make the tips round.

3. Draw a circle for a snail and add the opening.

4. Draw a spiral in the center of the snail. Start the whelk by drawing an elongated triangle with a curved top.

5. Add the spirals and the opening to the whelk. Let's make a star, too!

6. Color your shells in your preferred scheme.

COUNTRY CUTE

In her free time this girl can be found foraging for food in her countryside surroundings, picking flowers to decorate her room and press in her journal, collecting eggs from her chickens, or busy in the kitchen creating home-baked delights.

The overall color scheme has a fall feel, even down to the red hair. The green is muted so it sits nicely against the browns and beiges.

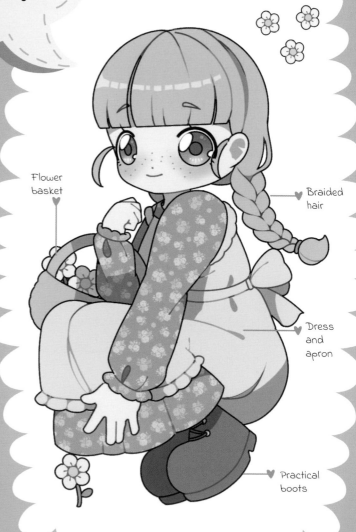

Flower basket

Braided hair

Dress and apron

Practical boots

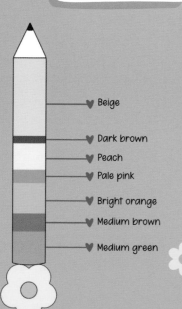

♥ Beige

♥ Dark brown

♥ Peach

♥ Pale pink

♥ Bright orange

♥ Medium brown

♥ Medium green

TOAST AND HONEY

CHICKEN

PRESSED FLOWER BOOK

MUSHROOMS

LET'S BAKE

BRAID

1. Start by drawing three lines next to each other. You now have two rectangle shapes.

2. Add diagonal, parallel lines, slightly offsetting them, inside each rectangle.

3. Join the diagonal lines with curved lines.

4. It's easy when you know how.

5. Color it.

CREATE THE CHARACTER

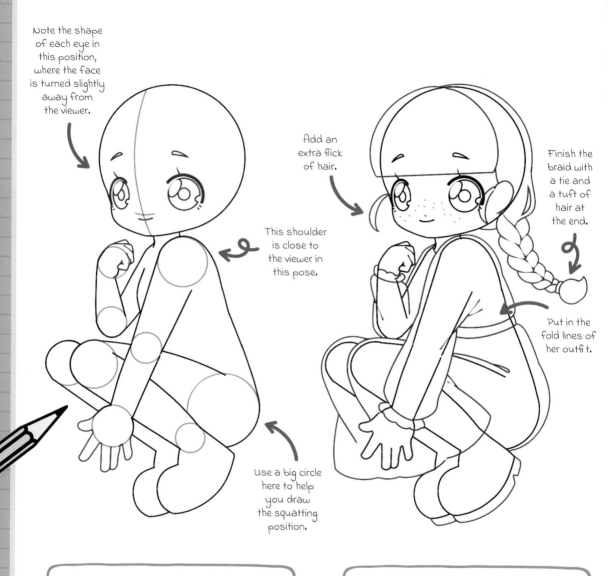

Note the shape of each eye in this position, where the face is turned slightly away from the viewer.

Add an extra flick of hair.

This shoulder is close to the viewer in this pose.

Finish the braid with a tie and a tuft of hair at the end.

Put in the fold lines of her outfit.

Use a big circle here to help you draw the squatting position.

1. This girl is picking flowers, so let's draw her in a squatting pose. Make the fingers open on one hand and closed on the other. Draw the facial features.

2. Add the bangs and a braid, and an ear on the right side of the face. Give her a comfy dress that tucks in at the waist, and long sleeves that tuck in at the cuffs. Add the soles of her boots, and freckles, too.

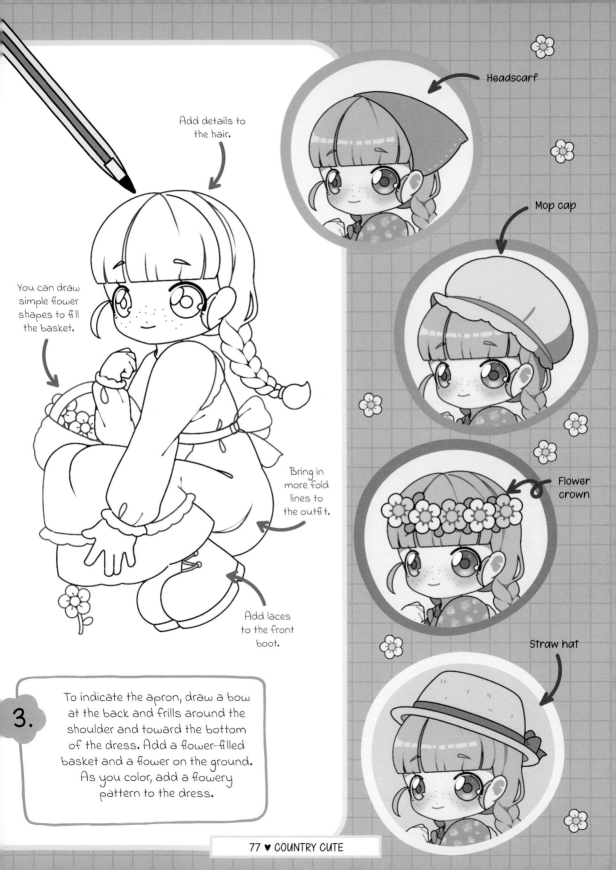

Add details to the hair.

You can draw simple flower shapes to fill the basket.

Bring in more fold lines to the outfit.

Add laces to the front boot.

3. To indicate the apron, draw a bow at the back and frills around the shoulder and toward the bottom of the dress. Add a flower-filled basket and a flower on the ground. As you color, add a flowery pattern to the dress.

Headscarf

Mop cap

Flower crown

Straw hat

ADD ACCESSORIES

LET'S BAKE

1. Draw a cylinder with an oval lid for the jar, and a wavy rectangle for the slice of toast.

1. Start with the bag of flour. Draw a rounded cube with a cylinder on top.

2. Draw two eggs. For the rolling pin, draw another cylinder.

2. Add a frilly top to the jar and the crust of the toast.

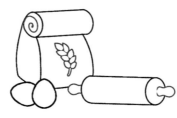

3. Give the rolling pin two handles, and draw a sheaf of wheat on the flour bag. Add a spiral to the top of the flour bag to show how it is rolled over.

3. Draw a smaller wavy rectangle inside the toast shape for the honey. Add a few drips of honey, too. Add details to the honey jar.

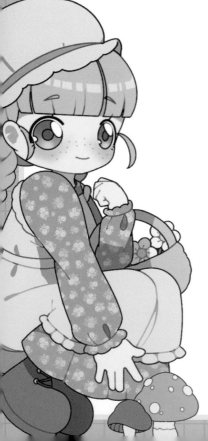

4. Color with browns and beiges.

4. Use fall-inspired colors to bring this tasty snack to life.

CHICKEN

1. Draw a wide oval for the body, a little head, and a big neck.

2. Add the chicken's face, crest, and a tail.

3. Draw a wing and a wavy line to make the neck look fluffy.

4. When coloring, add some shading to the tips of the wing and tail.

PRESSED FLOWER BOOK

1. Draw two rectangles side by side.

2. Draw parallel lines to the left and underneath the shape, for the book's covers. Draw pages inside the base shape.

3. Add a few lines in between the pages to give the impression of more pages. Draw a pressed flower with a rectangle of tape over it.

4. Color the book's covers in a darker shade than the pages.

MUSHROOMS

1. Start with the cap of the mushroom and add a long, round shape underneath it.

2. Add some spots on the cap and a ring on the base, under the cap.

3. Use the same technique to draw a smaller mushroom, this time showing the inside of the cap.

4. If you want to, use different colors for your mushroom caps.

FLOWER FAIRY

You are very unlikely to spot this fairy in the forest, since her leaf wings and petal dress act as natural camouflage. However, if you see an acorn flying past your eyes you'll know she's close by, because this prankster loves nothing more than confusing humans with her slingshot.

The colors of flowers and foliage are the inspiration for this scheme, and the leaf wings are complemented by a flower-petal skirt and sleeves.

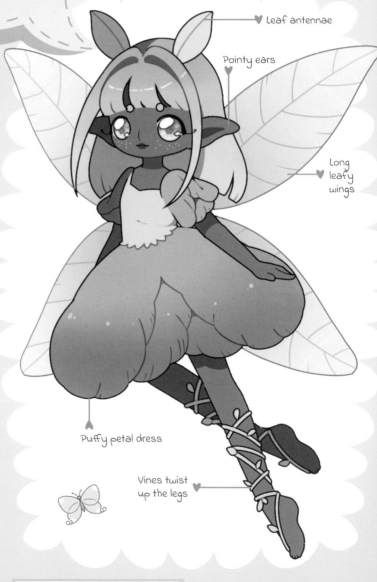

♥ Leaf antennae

♥ Pointy ears

♥ Long leafy wings

♥ Puffy petal dress

♥ Vines twist up the legs

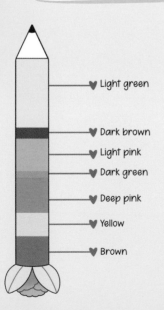

♥ Light green

♥ Dark brown

♥ Light pink

♥ Dark green

♥ Deep pink

♥ Yellow

♥ Brown

PAN PIPES

ACORN

SLINGSHOT

BEETLE

LEAF UMBRELLA

1. Draw an oval for the butterfly's body and add a tiny round head and two antennae.

2. For the top wing section, draw a figure eight on its side. Add smaller bottom wing sections.

3. Make the top wings pointed and add flourishes to the bottom wings.

4. Color in shades of pink, with white dots at the wing tips.

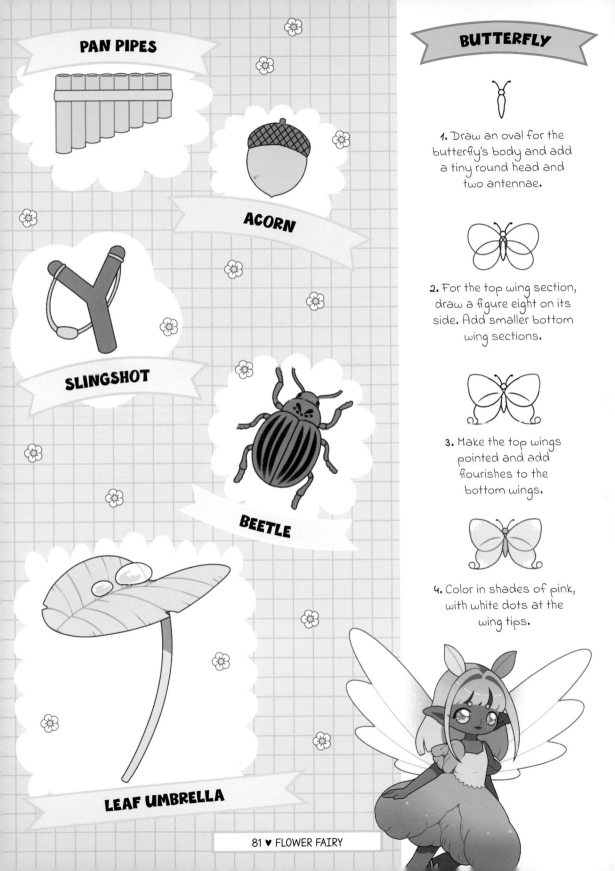

CREATE THE CHARACTER

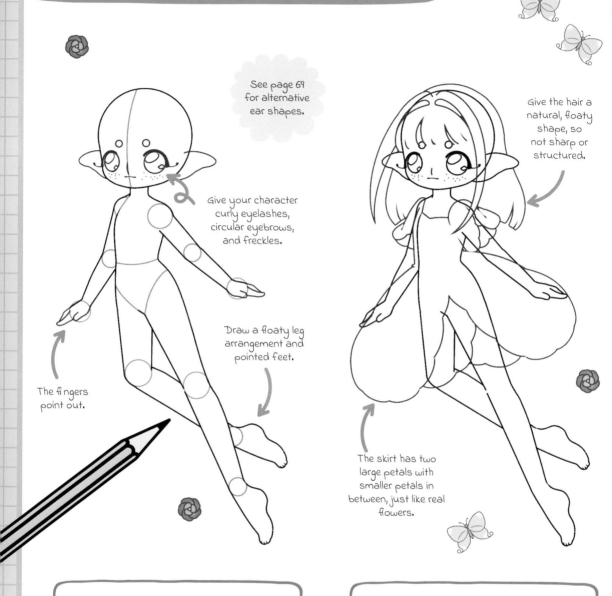

See page 69 for alternative ear shapes.

Give your character curly eyelashes, circular eyebrows, and freckles.

The fingers point out.

Draw a floaty leg arrangement and pointed feet.

Give the hair a natural, floaty shape, so not sharp or structured.

The skirt has two large petals with smaller petals in between, just like real flowers.

1. To give the impression that this character is flying, position her arms and legs slightly back from her body, with her feet pointed to show they don't touch the ground. Give her pointy ears and facial features.

2. Draw long hair and bangs. Keep the bodice of the dress close to the body, but draw the sleeves and skirt like petal shapes.

The leaf antennae have just one central vein each.

Feather wings

When coloring, make sure this arm is in front of the skirt, while the other arm is behind.

Luna moth wings

Add little leaves on the vines.

Monarch butterfly wings

3. Draw leaf-shaped wings behind the character, and leaf antennae. Add vines twisting up her legs and a frill where the bodice meets the skirt of the dress. When coloring, add in the veins on the leaves.

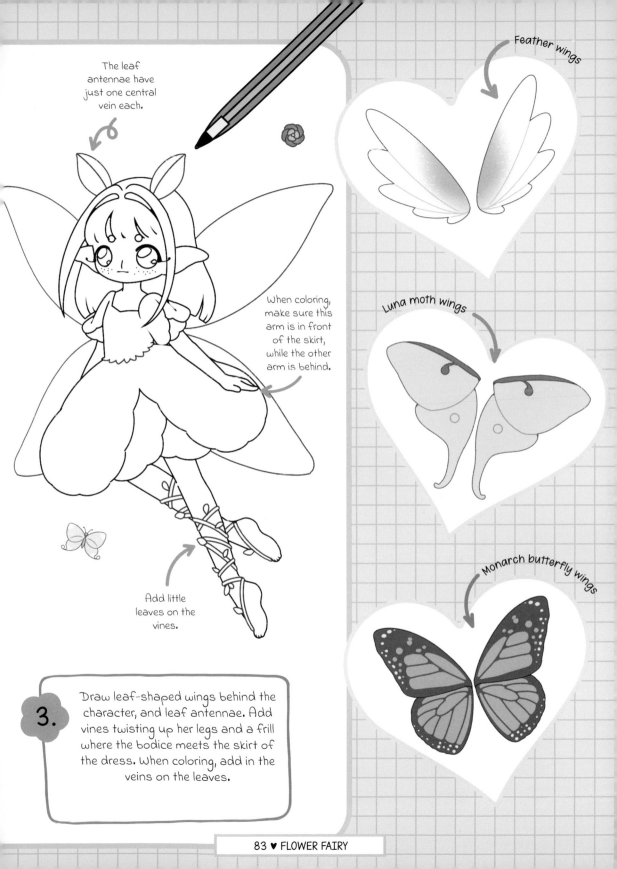

ADD ACCESSORIES

SLINGSHOT

1. Draw a chunky "Y" shape.

BEETLE

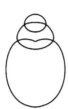

1. Start with a circle for the head, a bigger circle for the thorax, and an elongated circle for the body.

2. Draw the antennae, eyes, and a vertical line down the center of the body—that's where the wings are hiding.

2. Add a string tied at the tops of the "Y" and looping behind it. Draw an oval in the center of the string—that's where the acorns go.

3. Draw three pairs of legs, each leg consisting of three segments. Add the body markings, making sure they are symmetrical.

4. When coloring, use a darker brown for the markings.

3. Finish by coloring.

ACORN

1. Draw a rounded shape with a pointy bottom.

2. Draw a cap on top with a little stalk.

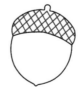

3. Criss-cross diagonal lines to make the pattern on the cap.

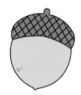

4. Color in shades of brown.

1. Draw a horizontal line with vertical lines down from each end. Make the vertical line longer on one side than the other. Join the vertical lines with a diagonal line.

2. Draw a series of rectangles of the same width inside the initial shape. You'll need to measure carefully to get the even effect.

3. Curve the bottom edges of the rectangles and add small ovals to the tops. Add the rectangle strap that holds all the pipes together.

4. Make the strap a different color from the pipes.

LEAF UMBRELLA

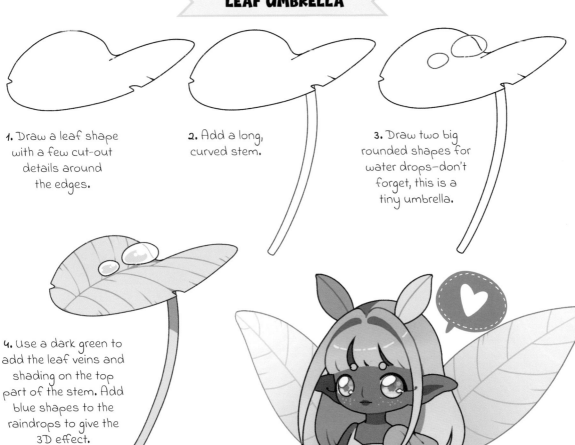

1. Draw a leaf shape with a few cut-out details around the edges.

2. Add a long, curved stem.

3. Draw two big rounded shapes for water drops—don't forget, this is a tiny umbrella.

4. Use a dark green to add the leaf veins and shading on the top part of the stem. Add blue shapes to the raindrops to give the 3D effect.

POWER FOR GOOD

She may look like an everyday girl, but with her wand, featuring a transformation amulet that turns ordinary liquids into magic potions, and a flying parasol, she is far from ordinary. What other magical accessories does she keep?

The pink and blue palette of her clothes is echoed in all of her magical accessories, including her pink puppy pet. Every now and then, pops of yellow break up the scheme.

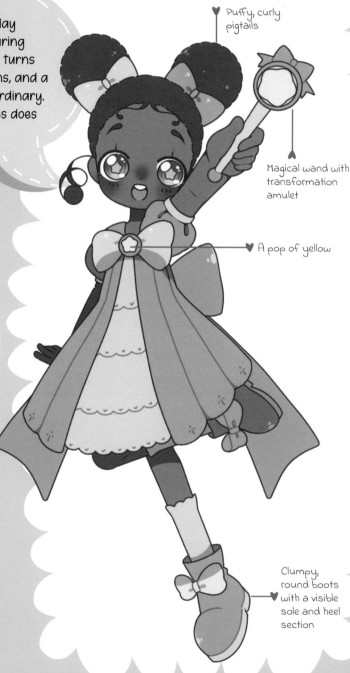

♥ Puffy, curly pigtails

♥ Magical wand with transformation amulet

♥ A pop of yellow

♥ Clumpy, round boots with a visible sole and heel section

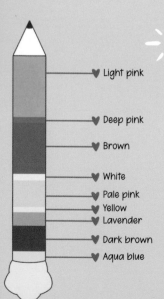

♥ Light pink

♥ Deep pink

♥ Brown

♥ White
♥ Pale pink
♥ Yellow
♥ Lavender

♥ Dark brown

♥ Aqua blue

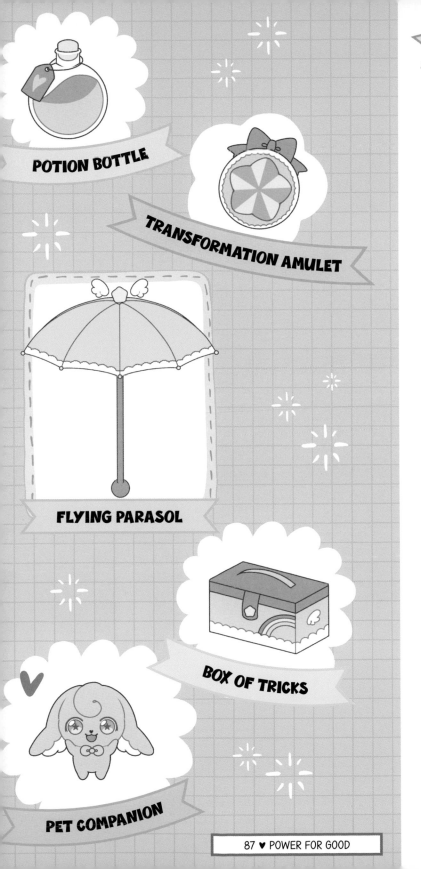

POTION BOTTLE

TRANSFORMATION AMULET

FLYING PARASOL

BOX OF TRICKS

PET COMPANION

POWER WAND

1. Draw a large circle, then the handle, with a smaller circle at the end.

2. Draw a transformation amulet (see page 90) in the big top circle.

3. Color the wand as imaginatively as you want. A stripy pattern on the handle looks great!

CREATE THE CHARACTER

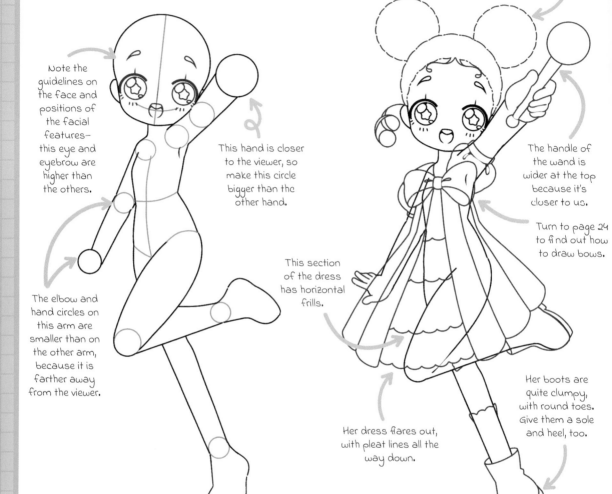

Note the guidelines on the face and positions of the facial features—this eye and eyebrow are higher than the others.

This hand is closer to the viewer, so make this circle bigger than the other hand.

The elbow and hand circles on this arm are smaller than on the other arm, because it is farther away from the viewer.

Simple circles form the pigtails.

The handle of the wand is wider at the top because it's closer to us.

Turn to page 24 to find out how to draw bows.

This section of the dress has horizontal frills.

Her dress flares out, with pleat lines all the way down.

Her boots are quite clumpy, with round toes. Give them a sole and heel, too.

1. Let's draw a dynamic pose! The girl is jumping, with one leg bent and the other one pointing down. Her head is facing forward but tilted slightly to one side, so pay attention to how you position the facial features.

2. Add two poofy pigtails and a curly wisp of hair above one ear. Draw her wand and wrap her fingers around it. Give her a flared dress with a bow in the center and short puff sleeves. Add the socks, boots, and fingers of the other hand.

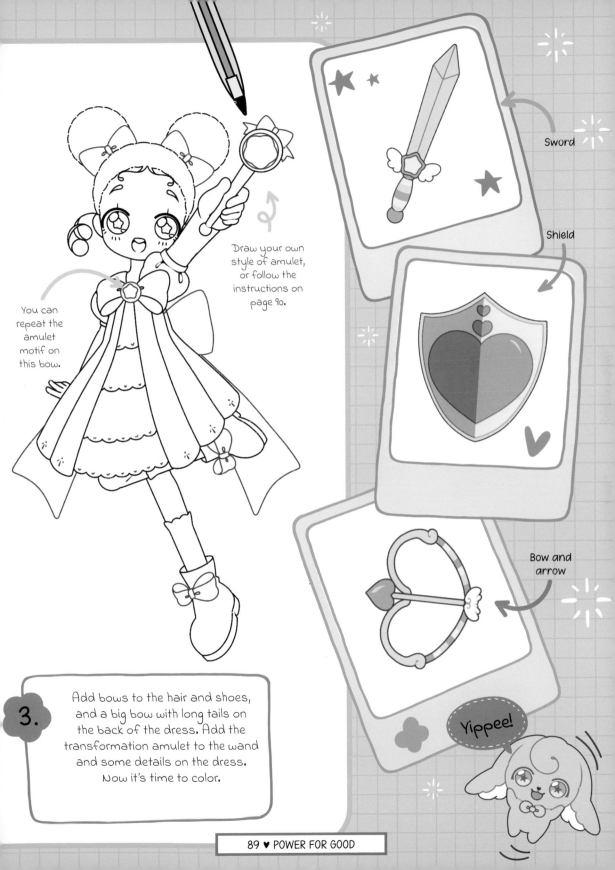

Draw your own style of amulet, or follow the instructions on page 90.

You can repeat the amulet motif on this bow.

Sword

Shield

Bow and arrow

3. Add bows to the hair and shoes, and a big bow with long tails on the back of the dress. Add the transformation amulet to the wand and some details on the dress. Now it's time to color.

Yippee!

ADD ACCESSORIES

TRANSFORMATION AMULET

1. Draw a circle with a five-pointed star in the center. You can make the star more rounded than usual, like this one, if you wish.

2. Add a bow on top, a frilly design around the star, and straight lines from the center of the star to break it into segments.

3. Alternate colors in each segment of the star to give a 3D effect.

1. Every magical girl needs a pet companion! Draw an elongated circle for the head and a little body with cute legs popping out! Add big round eyes in the bottom part of the face, and a happy smile!

BOX OF TRICKS

1. A girl needs to keep her magical accessories safe, in a magical box of course. Start with a cuboid and add two parallel lines for the lid.

2. Add a handle on top and a strap and star-shaped button on the front.

2. This pet is always cheering on their magical friend, so let's make the arms raised! This pet uses its ears to fly, so make them long and flare them out from the body. Add a little wisp of hair and a bow around the neck.

3. Add decorations, such as clouds, a rainbow, and a cute wing on the side.

4. Color your box using pinks, yellow, and blue, and leave the clouds and wing white.

3. Use the pink and blue color scheme, with yellows for the eyes.

POTION BOTTLE

1. Start with a circle for the bottle with an overlapping curved square on top.

2. Draw a fluid shape inside the bottle to represent the liquid, and a stopper in the top.

3. Draw a curved line around the center of the stopper to indicate the top of the bottle opening, and add a tag.

4. When coloring, make the liquid darker at the top; this helps to make the bottle look rounded.

FLYING PARASOL

 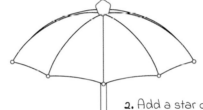

1. Draw a single curved line for the top of the parasol. Draw a straight line down the center front, and curved lines either side that echo the curve of the very first line. Join each of the lines at the bottom with a gently curving line.

2. Add a star on top of the parasol, a handle underneath, and a circle at the bottom of the handle. Add a little circle to the end of each arm of the parasol.

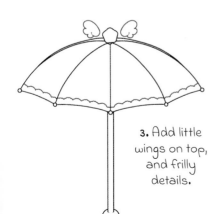 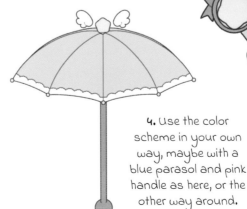

3. Add little wings on top, and frilly details.

4. Use the color scheme in your own way, maybe with a blue parasol and pink handle as here, or the other way around.

R-TRO GAM-R

The latest consoles are great, but this character also loves collecting retro tech and playing the games his parents used to love. He shops in thrift stores and finds bargains that he can fix up like new.

The muted color palette suits this character's laid-back style. He wears baggy pants and cool T-shirts over long-sleeved base layers.

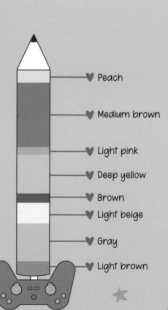

- ♥ Peach
- ♥ Medium brown
- ♥ Light pink
- ♥ Deep yellow
- ♥ Brown
- ♥ Light beige
- ♥ Gray
- ♥ Light brown

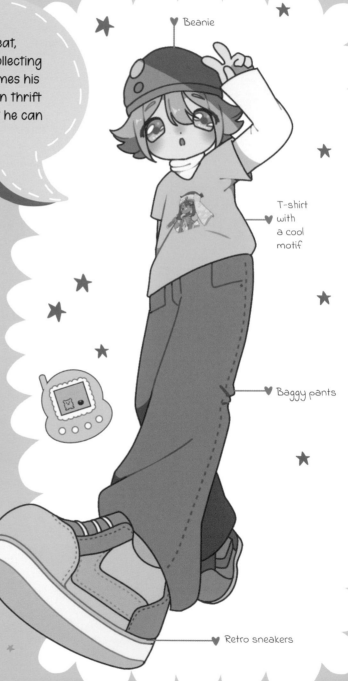

- ♥ Beanie
- ♥ T-shirt with a cool motif
- ♥ Baggy pants
- ♥ Retro sneakers

HEADPHONES

GAMING COMPUTER

CONSOLE CONTROLLER

ARCADE MACHINE

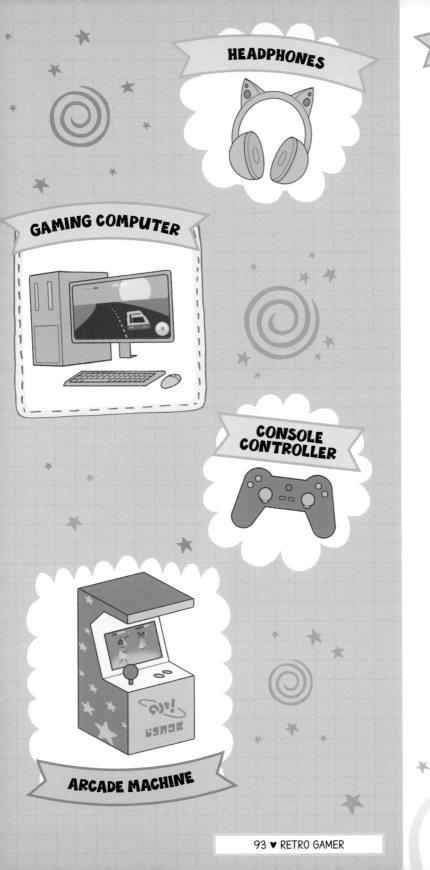

VIRTUAL PET

1. Start with a symmetrical bumpy base shape.

2. Draw a screen in the top part and buttons in the bottom section.

3. Add an antenna and your pixel pet on the screen! You can add details around the screen too!

4. Color the game to match your character's clothes.

CREATE THE CHARACTER

The sketch might look strange at first, but trust the process!

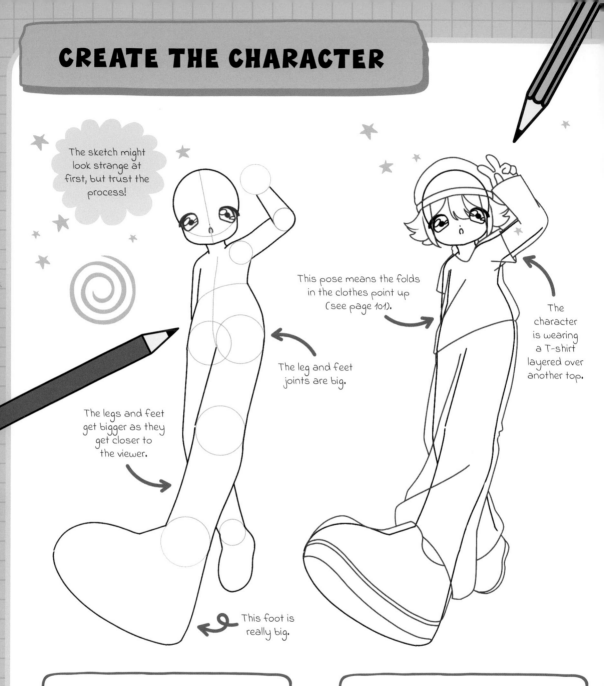

This pose means the folds in the clothes point up (see page 101).

The character is wearing a T-shirt layered over another top.

The leg and feet joints are big.

The legs and feet get bigger as they get closer to the viewer.

This foot is really big.

1. For this pose it is as if we're on the ground looking up at the character. Start by drawing the head and the face looking down. Draw the torso's guidelines slightly pointing up and make the parts of the body bigger as they get closer to us.

2. Draw the clothes, hair, hat, and hands. The pants are loose and get even looser near the shoes. Start adding the shoe details.

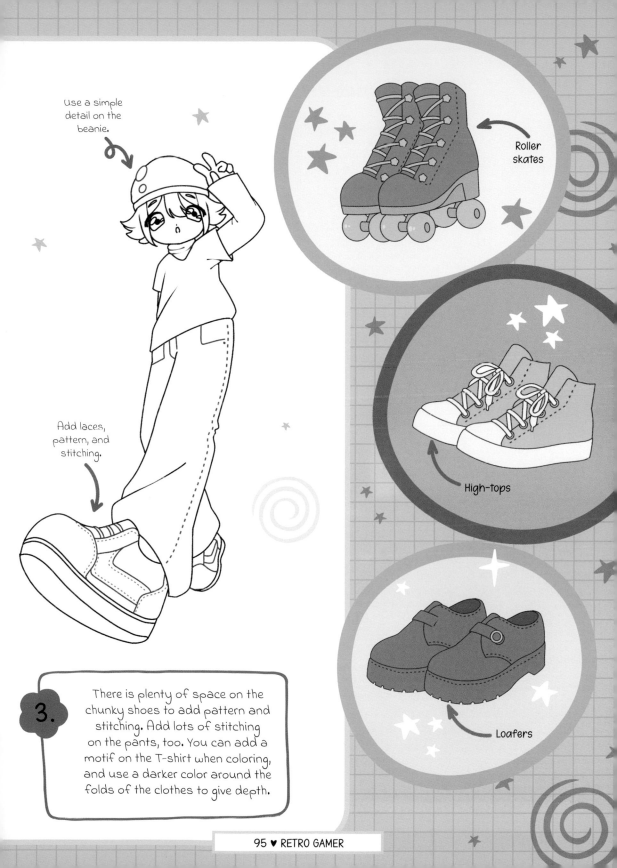

Use a simple detail on the beanie.

Add laces, pattern, and stitching.

Roller skates

High-tops

Loafers

3. There is plenty of space on the chunky shoes to add pattern and stitching. Add lots of stitching on the pants, too. You can add a motif on the T-shirt when coloring, and use a darker color around the folds of the clothes to give depth.

ADD ACCESSORIES

1. Start with the curved side pieces and join them with parallel horizontal lines.

2. Add the joysticks.

3. Add the buttons.

4. Get coloring!

GAMING COMPUTER

1. Draw a rectangle that is tilted toward the viewer. Add parallel lines all around.

2. Draw the computer's stand and a long cube for the tower.

3. Draw the details on the tower and a parallelogram for the keyboard.

4. Draw the keys on the keyboard and the mouse.

5. Draw and color in your favorite computer game.

HEADPHONES

1. Start with two half spheres and connect them over the top with a curved line.

2. Draw a thicker headband around the curved guideline.

3. Draw the cushions on the earpieces.

4. Let's add cat's ears on the headband!

5. Color the headphones.

ARCADE MACHINE

1. Start by drawing a tall cube with one corner facing the viewer.

2. Draw guidelines to help you place the opening on the machine.

3. Draw the opening and don't forget to erase the guidelines.

4. Add the screen, joystick, and buttons.

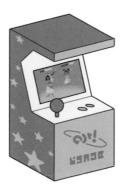

5. When coloring, add a suitably retro game and patterns on the machine.

SLEEPY HEAD

After a busy day, there's nothing better than snuggling up in a cozy onesie before bed. This girl takes her bedtime routine very seriously. She washes her face and hands and likes to apply lavender-scented creams, then she tucks herself in bed to write her diary, before lights out and mask on for a rejuvenating night's sleep.

Bedtime clothes should look comfortable, so we want to make them look soft and baggy. Light blues and purples are calming colors, so they're perfect for encouraging a good night's sleep.

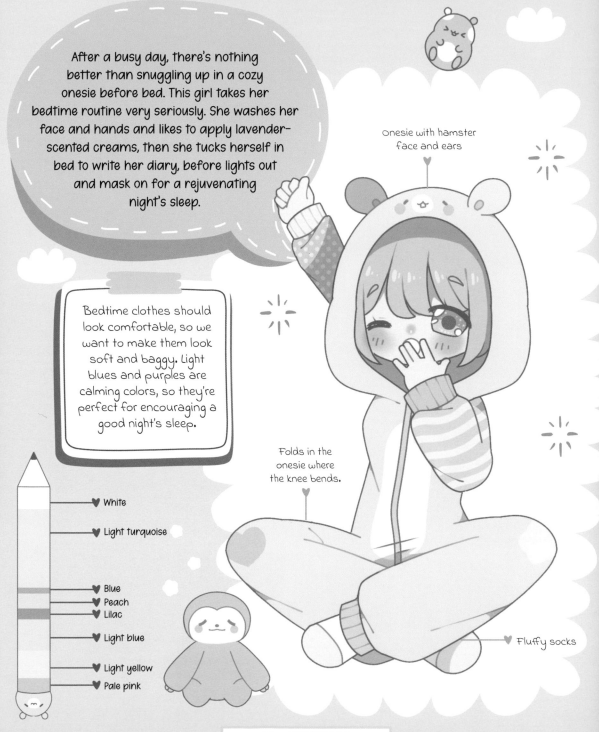

onesie with hamster face and ears

Folds in the onesie where the knee bends.

Fluffy socks

♥ White

♥ Light turquoise

♥ Blue
♥ Peach
♥ Lilac

♥ Light blue

♥ Light yellow

♥ Pale pink

HEART PILLOW

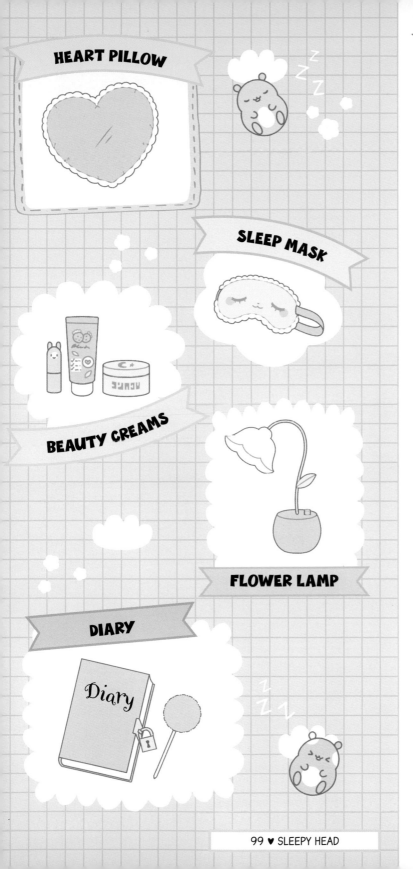

SLEEP MASK

BEAUTY CREAMS

FLOWER LAMP

DIARY

Diary

1. Start with a wide oval for the head and a tall oval for the body.

2. Draw a sleepy sloth face.

3. Add long arms with two claws each and short legs.

4. When coloring, give your sloth rosy cheeks.

CREATE THE CHARACTER

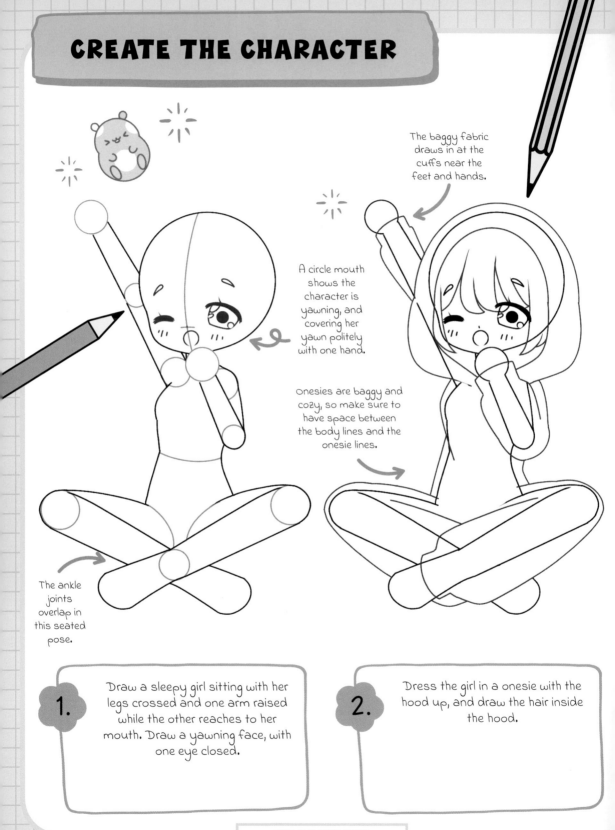

The baggy fabric draws in at the cuffs near the feet and hands.

A circle mouth shows the character is yawning, and covering her yawn politely with one hand.

Onesies are baggy and cozy, so make sure to have space between the body lines and the onesie lines.

The ankle joints overlap in this seated pose.

1. Draw a sleepy girl sitting with her legs crossed and one arm raised while the other reaches to her mouth. Draw a yawning face, with one eye closed.

2. Dress the girl in a onesie with the hood up, and draw the hair inside the hood.

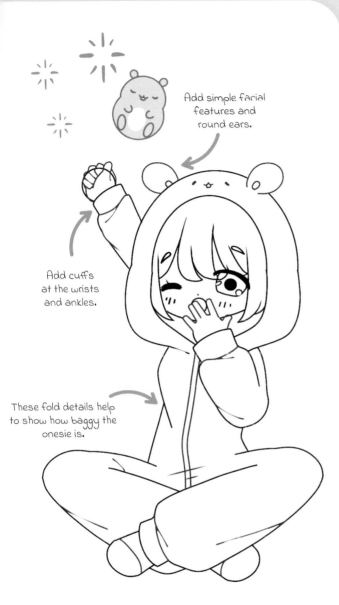

Add simple facial features and round ears.

Add cuffs at the wrists and ankles.

These fold details help to show how baggy the onesie is.

3. Draw outstretched fingers on the hand covering the yawn, and closed fingers on the other hand. Add hamster details on the hood, a zipper down the front of the onesie, and the finishing folds and tucks, then get coloring.

DRAWING FOLDS

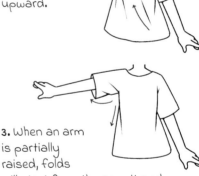

1. In this position, the folds in clothes point downward. There are folds at the armpits. If the clothes are loose, add fold lines to indicate that, in this case below the chest.

2. When an arm is fully raised, the shirt will rise a bit, and all the folds will point upward.

3. When an arm is partially raised, folds will start from the armpit and follow their way up to the arm. The folds on the rest of the body stay pointing down.

4. Pants have folds where the legs meet, on the back of the knees, and at the ankles.

ADD ACCESSORIES

HEART PILLOW

1. Draw a heart.

2. Add a line of frills around the heart.

1. Draw a bean shape to start the mask.

3. Add some folds on the frills of the pillow and on the center to make it look plump and squishy.

4. Now for the coloring.

2. Draw a strap coming out from one side of the mask.

3. Add frills all around the mask and a cute sleepy face!

FLOWER LAMP

1. Draw a round shape like a plant pot, with an oval on top. Add a curved "stem" growing out from the pot.

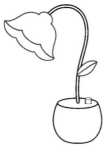

2. Draw a three-petaled flower for the lamp, plus a leaf near the base of the "stem." Add a button.

3. Color it in to finish.

4. Give the face rosy cheeks as you color it.

DIARY

 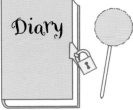

1. Start with a rectangle.

2. Add lines along the bottom and right edges of the rectangle to make the diary look 3D.

3. Draw a catch and padlock on the side of the diary for privacy.

4. When coloring, use your favorite lettering style to write the word "Diary."

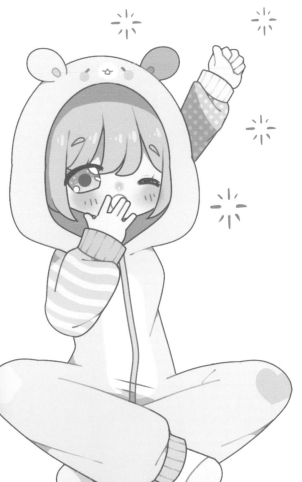

BEAUTY CREAMS

1. Draw a triangular shape with a lid on the bottom to make a hand cream bottle, and a circular tub for a jar of moisturizer. Draw a small rectangle with a rounded top for a tube of lip balm.

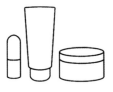

2. Add tiny pictures and lettering to your products.

3. Use a different color for each product.

FLYING HIGH

When night falls, this character jumps on her broom and flies off to collect plants for her potions and meet her ghost friends. Witches are known for having companion animals, often called "familiars," who carry out tasks for them. This character's companion is a frog, but you could choose your favorite animal instead.

The colors used on the dress and hat are like those in the night sky, and gradate through shades of purple and blue.

Pointy hat with astrological motifs

Magical stars in her hair

Starry-sky themed dress

A broom to fly on

♥ Lavender
♥ Pale yellow
♥ Pale blue
♥ Peach
♥ Pink
♥ Light yellow
♥ Medium brown
♥ Light blue

Pointy boots match her pointy hat

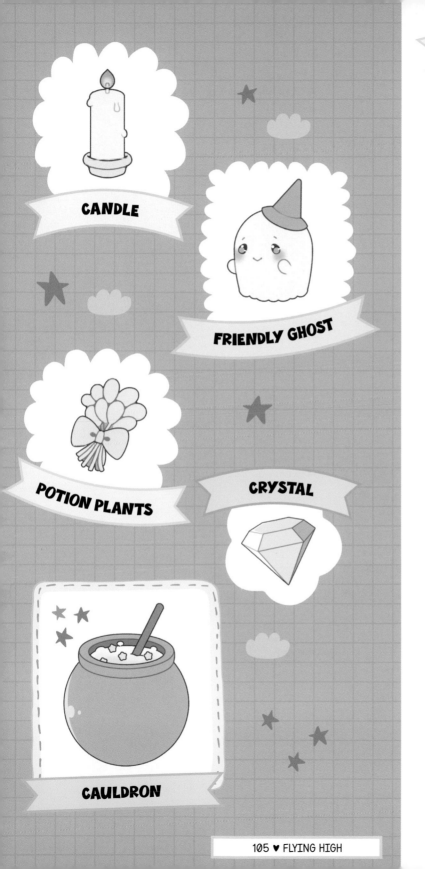

CANDLE

FRIENDLY GHOST

POTION PLANTS

CRYSTAL

CAULDRON

1. Draw two overlapping ovals—one for the head and a bigger one for the body.

2. Add rounded shapes for the legs, and give them little toes.

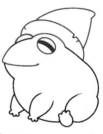

3. Add the eyes and mouth, and a little pointy hat.

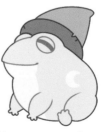

4. You can even give your character astrological motifs when you color it.

CREATE THE CHARACTER

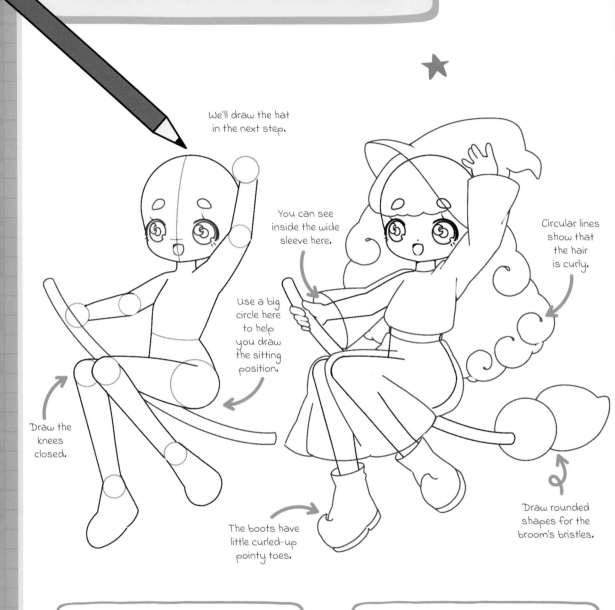

We'll draw the hat in the next step.

You can see inside the wide sleeve here.

Circular lines show that the hair is curly.

Use a big circle here to help you draw the sitting position.

Draw the knees closed.

The boots have little curled-up pointy toes.

Draw rounded shapes for the broom's bristles.

1. Draw your character in a sitting pose, then add the broomstick underneath her. Have her hold the broom with one hand while she holds her hat with the other.

2. Give her curly long hair and bangs. Her dress covers her knees and has wide sleeves. Draw a pointy hat and boots with curled-up pointy toes. Don't forget to add the broom's bristles!

Add details to the hair if needed.

Have fun drawing moon and star motifs.

Give the bristles detail lines.

Add fold lines to the dress.

A few criss-cross lines make the laces.

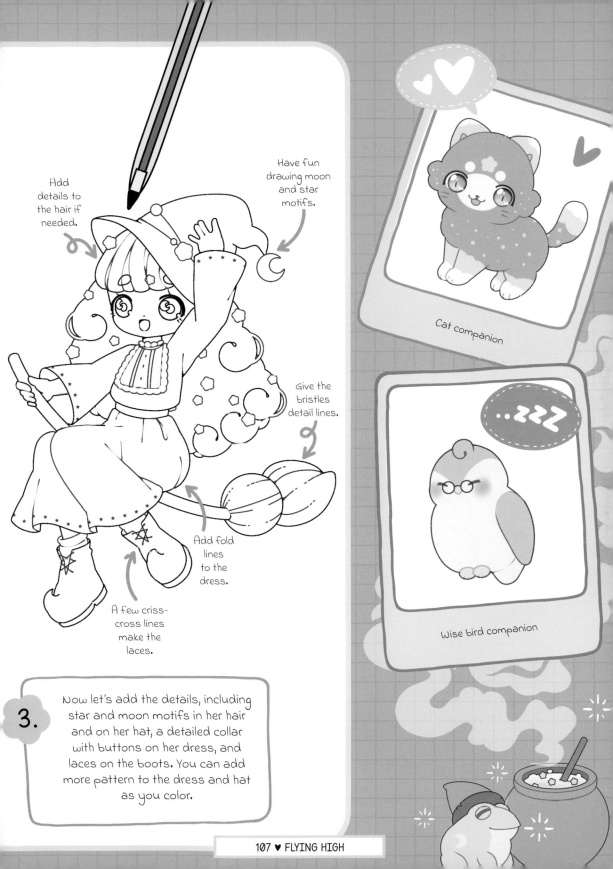

Cat companion

...zzz

Wise bird companion

3. Now let's add the details, including star and moon motifs in her hair and on her hat, a detailed collar with buttons on her dress, and laces on the boots. You can add more pattern to the dress and hat as you color.

ADD ACCESSORIES

CRYSTAL

CANDLE

 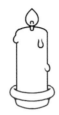

1. Start with a long rectangle with a rounded top.

2. Add some wax drops and a flame.

3. Don't forget to add a holder under the candle!

4. Color in the candle, flame, and holder.

1. To draw a diamond-shaped crystal, start with an elongated hexagon for the top.

POTION PLANTS

1. Our character collects plants to make her potions. Start with a tuft of leaves.

2. Add a bow underneath the leaves.

3. Add the plants' stems under the bow.

4. Make the plants green and the bow blue to match the character's dress.

2. Add another, bigger hexagon below the first, and an upside-down triangle under that.

3. Draw straight lines to create the facets of all the shapes.

4. Color the crystal using all three shades of blue.

1. Start with a rounded shape with an almost straight base.

2. Add big eyes and a mouth. Overlap the bottom line with a wavy line.

3. Add little round arms and a pointy hat.

4. When coloring, give your ghost little rosy cheeks.

CAULDRON

1. Start with a circle.

2. Draw an oval for the opening of the cauldron, and give it a rim.

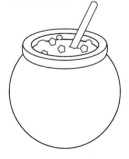

3. Add the cauldron contents. This is a potion with added stardust. Don't forget to add a big spoon!

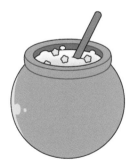

4. Color the cauldron and its contents. Note the light blue highlight on the left of the pot.

KEMONOMIMI CAT

Kemonomimi characters have animal ears and a tail. Our character is a cat kemonomimi, but yours can have the ears and tail of any animal you choose. Give them accessories that suit their animal—in this case a ball of yarn, a fish toy, and a collar with a bell.

This kemonomimi cat is a tabby, with shades of brown and pink highlights. You could make yours a black-and-white cat or an orange tabby.

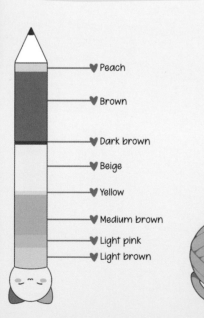

- ♥ Peach
- ♥ Brown
- ♥ Dark brown
- ♥ Beige
- ♥ Yellow
- ♥ Medium brown
- ♥ Light pink
- ♥ Light brown

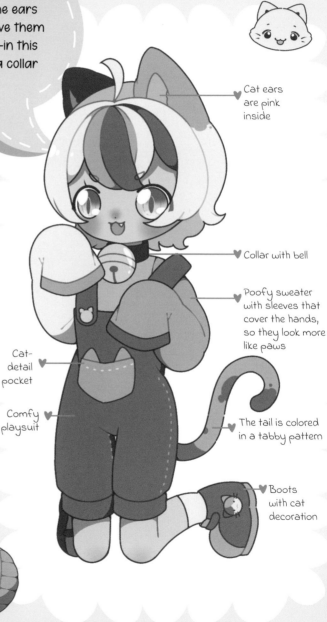

Cat ears are pink inside

Collar with bell

Poofy sweater with sleeves that cover the hands, so they look more like paws

Cat-detail pocket

Comfy playsuit

The tail is colored in a tabby pattern

Boots with cat decoration

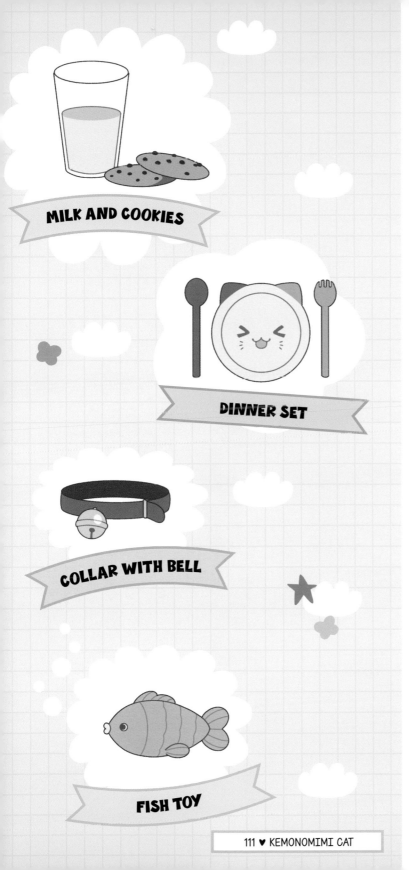

MILK AND COOKIES

DINNER SET

COLLAR WITH BELL

FISH TOY

BALL OF YARN

1. Start with a circle. Simple!

2. Add a series of criss-crossing, curved parallel lines inside the circle and a loose string of yarn coming out from the bottom.

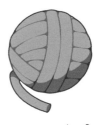

3. Use any color for your yarn, but use a darker shade to mark out the lines. This ball has shading on the bottom right to show that it is resting on a surface, not floating in space.

CREATE THE CHARACTER

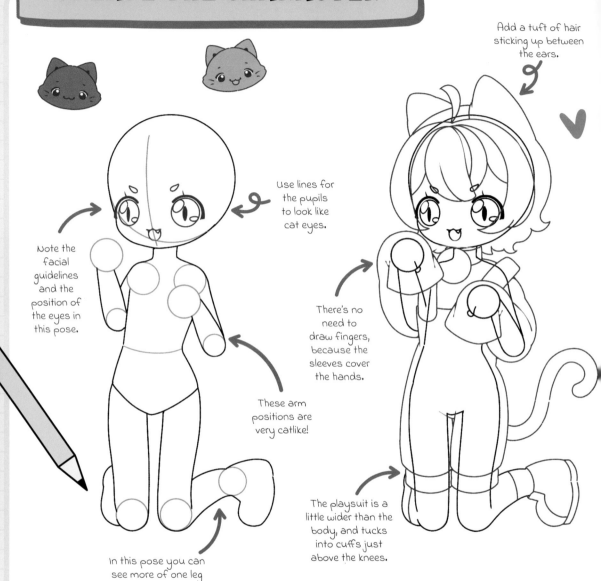

Add a tuft of hair sticking up between the ears.

Use lines for the pupils to look like cat eyes.

Note the facial guidelines and the position of the eyes in this pose.

There's no need to draw fingers, because the sleeves cover the hands.

These arm positions are very catlike!

The playsuit is a little wider than the body, and tucks into cuffs just above the knees.

In this pose you can see more of one leg than the other.

1. Use the circles at the joints to guide the positioning of the arms and legs in this cute, catlike pose. Note that the character is not facing full front, but at a slight angle. Add the eyes with sharp pupils and a cute cat mouth.

2. Draw curved shapes for the hair and pointy cat ears. Add the sweater sleeves—they widen at the end as they cover the hands. Draw a collar with a big circle for a bell, then the playsuit, boots, and, of course, a long cat tail.

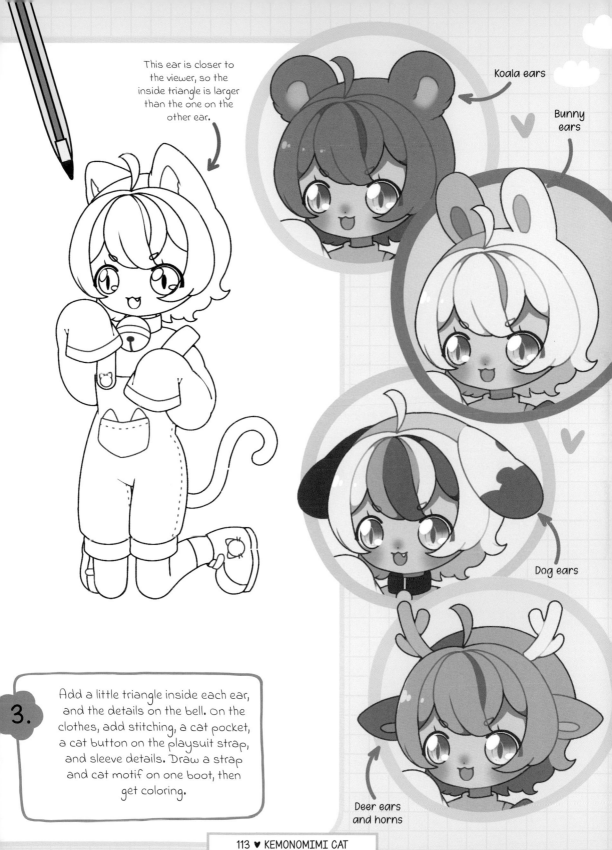

This ear is closer to the viewer, so the inside triangle is larger than the one on the other ear.

Koala ears

Bunny ears

Dog ears

Deer ears and horns

3. Add a little triangle inside each ear, and the details on the bell. On the clothes, add stitching, a cat pocket, a cat button on the playsuit strap, and sleeve details. Draw a strap and cat motif on one boot, then get coloring.

ADD ACCESSORIES

MILK AND COOKIES

1. Cats love milk and we all love cookies! Draw a cup shape with an oval at the top. From this perspective the cookies are also ovals.

2. Draw a smaller cup shape inside the first cup to indicate the milk. Add chocolate chips to the cookies.

3. Use beige for the milk, with light brown on top to make the cup look rounded.

COLLAR WITH BELL

1. Start the collar by drawing a single, elongated oval.

2. Add another oval underneath the first one and connect the two with a curved line at each end.

3. Add a circle for the bell, then fill in the details. Draw the end of the strap and the collar's catch.

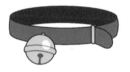

4. Our kemonomimi cat has a brown collar to match its clothes, but you could give your character a more colorful option.

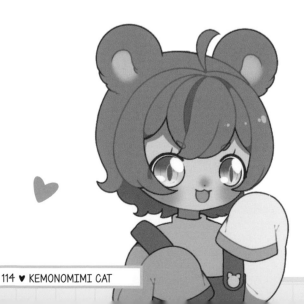

1. Draw an eye shape for the fish outline.

2. Add fins on the top and bottom, and a tail at the back.

1. Let's begin with a circle and two long rectangles.

3. Add an eye and mouth, a curved line to indicate the head, and wavy lines for the scales.

4. When coloring, you can add line details to the fins and tail.

2. Draw a smaller circle inside the first one, and add cat ears to the top of the plate. For the cutlery, start by adding ovals on top of each rectangle. Draw the prongs on the fork.

3. While coloring you can add a cat face inside the plate, or try drawing your favorite food instead!

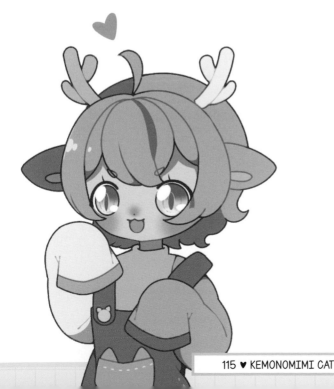

STEAMPUN SCIENTIST

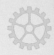

Steampunk is a science-fiction genre that mixes industrial steam machinery with a retro-futuristic look. Our steampunk scientist is dedicated to improving the future for all with her discoveries, inventions, and creations. Her clockwork time-machine backpack is her greatest achievement . . . so far!

The steampunk color scheme is based on wood, leather, and industrial metals such as brass. Splashes of green liven things up.

The colors and frills in this hat echo those in her whole outfit.

♥ Round glasses

The bodice of her dress is fastened with ties.

♥ Yellow

♥ Gray

♥ Peach

♥ Forest green

♥ Dark brown

♥ Beige

♥ Pale brown

♥ Medium brown

♥ Brown

♥ Light brown

Criss-cross laces echo the dress ties.

TOP HAT

TOOLBOX

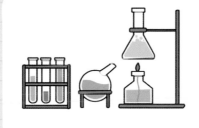

LABORATORY GLASSWARE

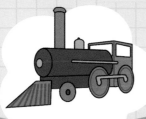

TRAIN ENGINE

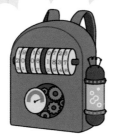

CLOCKWORK TIME MACHINE

1. Draw a circle connected to an oval by a slim hinge.

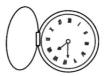

2. Draw a clock face inside the circle.

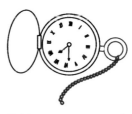

3. Add a ring on one side, then draw lots of small, connected circles to make a chain.

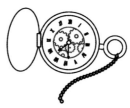

4. Draw a circle in the center of the clock face and add the gear mechanism.

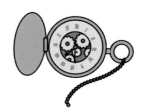

5. Color all the elements.

CREATE THE CHARACTER

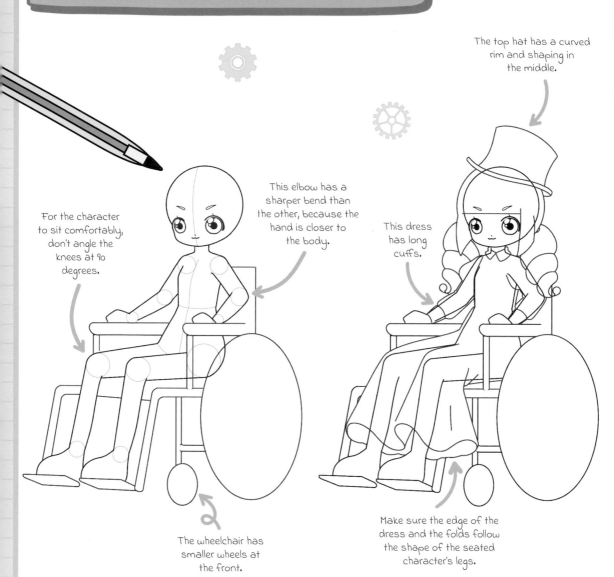

The top hat has a curved rim and shaping in the middle.

This elbow has a sharper bend than the other, because the hand is closer to the body.

For the character to sit comfortably, don't angle the knees at 90 degrees.

This dress has long cuffs.

The wheelchair has smaller wheels at the front.

Make sure the edge of the dress and the folds follow the shape of the seated character's legs.

1. Start by drawing the head and torso, then sketch in the wheelchair. Add the seated legs next, then add the facial features.

2. Add two curly pigtails and bangs, and a top hat. Draw the dress close to the body until you reach the waist, then give the skirt a flowing shape. Draw a neat collar and long sleeves that tuck into long cuffs.

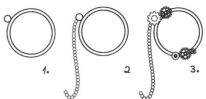

Add a frill detail on the hat that ties in with the rest of the outfit.

Draw the glasses so they rest on the nose and don't completely cover the eyes.

Little crosses indicate the ties on the bodice of the dress.

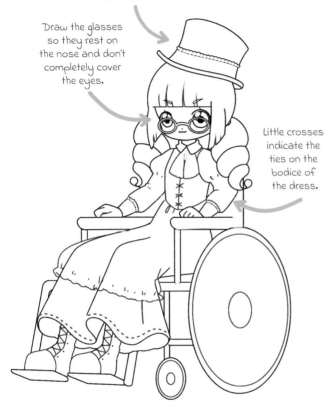

MONOCLE

1. 2 3.

1. Start with a ring and draw a circle at top-left.

2. Draw lots of small, connected circles down from the ring to make a chain.

3. Add some gears around the monocle frame for decoration.

4.

4. When coloring, include bright diagonal highlights to indicate the glass face.

GOGGLES

1. Start with two rings.

1.

2. Connect the rings with a horizontal line over the top that then follows the shape of the rings around the sides and rises up where the nose will be.

2.

3. Draw the strap on each side and add some details on the mask.

3.

4. Color your goggles.

4.

3. Draw the apron on top of the skirt and her round glasses. Add ties, folds, frills, and stitching details to the outfit, and draw the boots. Draw her hands resting on the arms of the chair and the chair's wheel details. Color in muted tones.

ADD ACCESSORIES

1. Draw two connected rectangles for the box sides. Draw another rectangle for the top and connect the lines to create a cuboid.

2. Draw the handle of the toolbox.

3. Add the tools inside the box! Let's try a hammer, screwdriver, saw, and spanner.

4. Color the box and the tools.

TOP HAT

1. Start with a narrow oval for the top. Draw vertical lines from the edges of the oval that curve slightly inward toward the bottom.

2. Draw a curved line for the brim.

3. Add a strap across the body of the hat.

4. Color the hat and the strap.

TRAIN ENGINE

1. Start with basic shapes: a cube and a horizontal tube.

2. Add circles for the wheels, a triangular shape for the plow at the front, and tubes for the chimney and whistle.

3. Add windows on the cabin, connect the back wheels, and draw in a few more details.

4. Use different colors for the various parts of the engine.

1. Draw three tubes, a round flask, and another flask on top of a burner.

2. Add the holders for the tubes and flasks.

3. Add the openings on the tubes. Draw a flame on the burner.

4. Use exciting colors for your experimental liquids inside the flasks and tubes.

CLOCKWORK TIME MACHINE

1. Start by drawing an arc with a flat base, facing slightly away from the viewer.

2. Echo the original lines over the top and to the right to make the machine look 3D.

3. Draw a tube in the top section of the shape and divide it into ten sections. At the bottom of the shape, draw two overlapping circles.

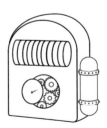

4. Draw a dial in the full circle, and cogs in the section next to it. Add a fuel pipe on the side.

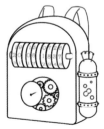

5. Add the date you want to travel to on the top tube. This time machine is a backpack, so add some straps, and finish with some bubbles in the fuel tube.

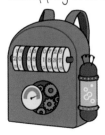

6. Color your time machine and get ready for adventure!

CYBORG SUPERHERO

This character's robotic arm means that he can swipe his enemies aside, while his eyes are implanted with lasers to burn through obstacles. His world is full of peril, so he always carries his gas mask and light sword, and a holographic communication device to keep in touch with his allies.

The outfit has a military feel. It needs to be useful, so it has pockets and straps for attaching accessories such as his sword and gas mask.

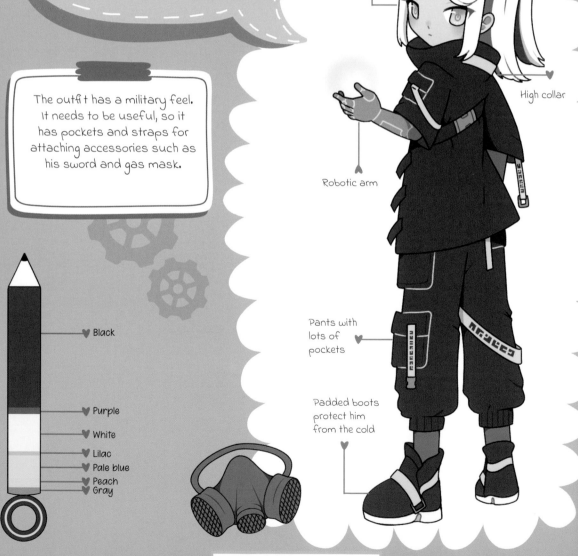

Mechanically implanted laser eyes

High collar

Robotic arm

Pants with lots of pockets

Padded boots protect him from the cold

Black

Purple
White
Lilac
Pale blue
Peach
Gray

ROBOT CROW

HOLOGRAM DEVICE

LIGHT SWORD

MECHANICAL WINGS

MOTORCYCLE

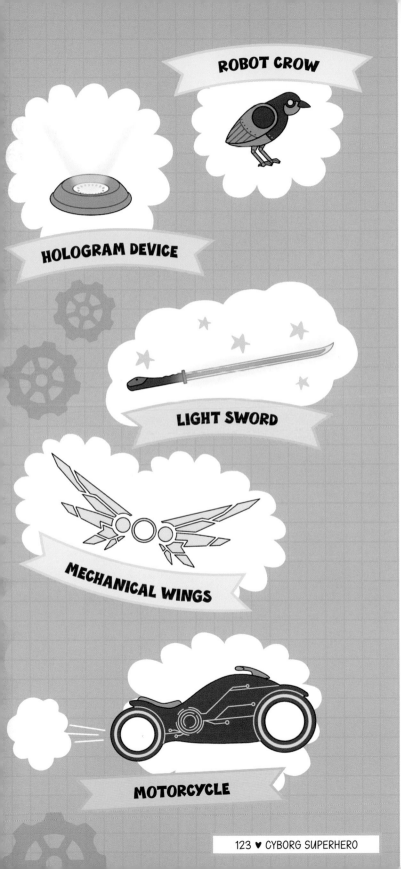

GAS MASK

1. Draw a curved, triangular shape.

2. Draw two ovals and parallel curved lines for the filter sections.

3. Draw a smaller version of the same shape in the middle of the mask, for the inhalation tube.

4. Add the strap and criss-cross protective grids on the tubes.

5. Color the mask, using a darker shade for the grid pattern.

CREATE THE CHARACTER

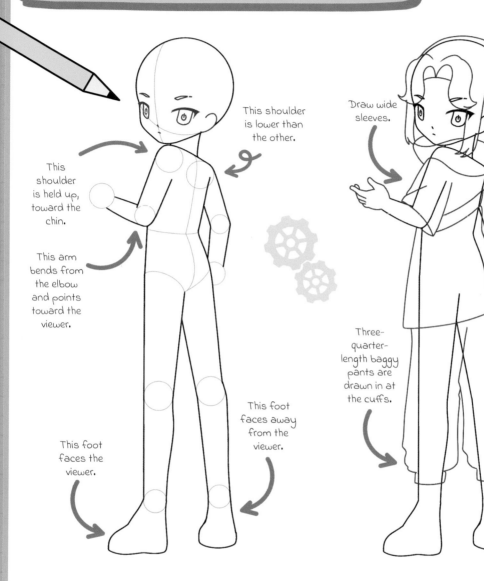

This shoulder is lower than the other.

This shoulder is held up, toward the chin.

This arm bends from the elbow and points toward the viewer.

This foot faces the viewer.

This foot faces away from the viewer.

Draw wide sleeves.

The jacket tapers in at the waist.

Three-quarter-length baggy pants are drawn in at the cuffs.

1. Draw this character with his back to the viewer, but turning slightly toward us, so his face is in a three-quarter position.

2. Draw long hair and wavy bangs. Give him baggy, three-quarter-length pants and a long jacket with wide sleeves. Draw in his partially open hand.

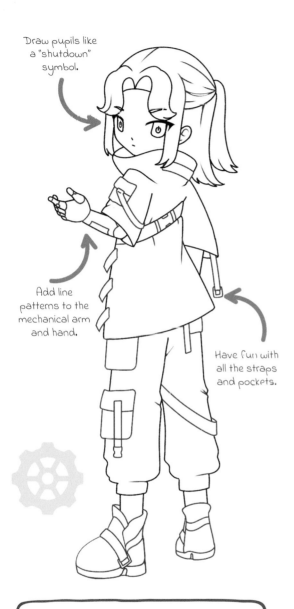

Draw pupils like a "shutdown" symbol.

Add line patterns to the mechanical arm and hand.

Have fun with all the straps and pockets.

3. Give him padded boots. Add as many pockets and straps to the outfit as you want. Draw circuit lines on his robotic arm and give him non-human pupils. When coloring, add a power blast from his part-open hand.

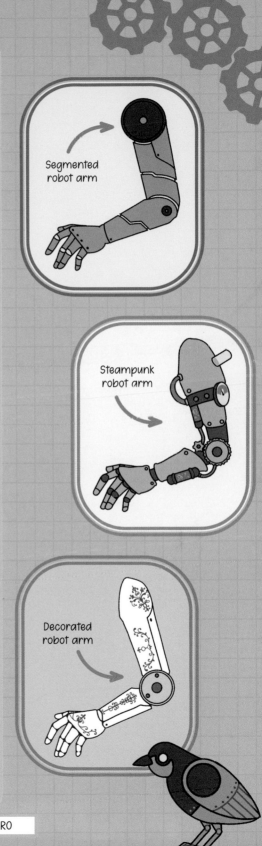

Segmented robot arm

Steampunk robot arm

Decorated robot arm

ADD ACCESSORIES

ROBOT CROW

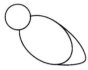

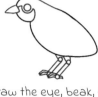

1. Start with a round head and an oval for the body. Add a rounded point at the bottom of the oval.

2. Draw the eye, beak, feet, and claws. Smooth out the joint between the head and body.

3. Draw a wing with a circle joint and rivets. Add some rivets to the body, too.

4. Use metallic colors for the bird, but go for a brighter, eerie color for the eye.

LIGHT SWORD

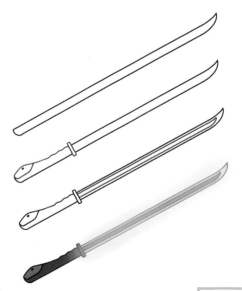

1. Start with the outline of the sword.

2. Draw the handle.

3. Draw a tube inside the blade.

4. Color the outside of the blade in a lighter shade than the inside.

HOLOGRAM DEVICE

1. Draw a wide oval and a smaller oval inside the first.

2. Echo the curved lines underneath the first ovals, and join them together with shorter curved lines.

3. Dot in the lights inside the device.

4. Color the device and add your choice of hologram.

1. Draw a ring with a circle on either side.

1. Start with rings for the wheels.

2. Add sharp, pointy wing shapes coming out of the circles.

2. Draw curved lines to make up the body of the motorcycle.

3. Split the wings into geometrical shapes.

3. Draw the seat and the hand clutch. Add circuit details.

4. Finish by coloring.

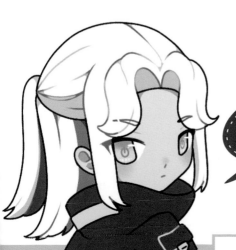

4. Color the vehicle so that it looks super futuristic.

INDEX